To Bob DeWeese, John Stewart, and Jimmie Lee Williams

PRENTICE-HALL, INC.
ENGLEWOOD CLIFFS, NEW JERSEY 07632

MARY FRISBEE JOHNSON

visual workouts

A COLLECTION OF ART-MAKING PROBLEMS

Library of Congress Cataloging in Publication Data

JOHNSON, MARY FRISBEE.
 Visual workouts.

 Bibliography.
 1. Art—Technique. 2. Art—Problems, exercises, etc.
I. Title.
N7430.J57 1983 702'.8 82-21448
 ISBN 0-13-942664-7

Interior and cover design:
 Jeff McGinnis
Editorial/production supervision:
 Chrys Chrzanowski
Interior layout: A Good Thing
Manufacturing buyer: Harry P. Baisley

Printed in the United States of America

10 9 8 7 6 5 4 3 2 1

ISBN 0-13-942664-7

PRENTICE-HALL INTERNATIONAL, INC., *London*
PRENTICE-HALL OF AUSTRALIA PTY. LIMITED, *Sydney*
EDITORA PRENTICE-HALL DO BRASIL, LTDA., *Rio de Janeiro*
PRENTICE-HALL CANADA INC., *Toronto*
PRENTICE-HALL OF INDIA PRIVATE LIMITED, *New Delhi*
PRENTICE-HALL OF JAPAN, INC., *Tokyo*
PRENTICE-HALL OF SOUTHEAST ASIA PTE. LTD., *Singapore*
WHITEHALL BOOKS LIMITED, *Wellington, New Zealand*

TABLE OF CONTENTS

PREFACE

This book is a collection of problems that puts the principles of two- and three-dimensional design into practical use. The focus of the problems, however, is on conceptualization and ideation within a problem-solving format. I have never felt that beginning artists must be limited by exercises that merely illustrate a single element of design in such a way that the results are inevitably labeled "basic design projects." Rather, I believe that many young artists, with the proper guidance, can produce young art. In any visual area, an artist combines thought and self-expression with media, process, and visual vocabulary to produce a finished piece. It is my contention that this melding of elements logically should begin right from the start.

Beginning artists, of course, do need some kind of structure to work within. The problems in this book provide a logical explorative format. They start with elements of the two-dimensional picture plane, gradually work into color explorations, and conclude with three-dimensional and sculptural ideas. They begin with basic concepts and principles that gradually become more complex and sophisticated. Within this order, each problem provides several things:

A problem-solving structure in which artists can explore their ideas, develop creative thinking skills, and define their interests and goals as artists.

An interesting concept that appeals to the imagination, holds the interest of beginning students, and promotes heightened perception. An opportunity, within a given concept, to use the visual vocabulary basic to all visual exploration.
The investigation of media and processes.

Because these problems stress thinking, self-exploration, and fundamental visual principles, they can be used effectively to prepare artists in any visual area, including studio art, design, crafts, or architecture. The strength of these problems lies in one important tenet: Thinking is an essential part of the art-making process. Concentration on ideation, problem-solving, and intuitive exploration will, in the long run, be more valuable to a creative person than learning the principles of visual design by rote. If young artists are provided with the thinking and creative processes to become imaginative and independent, they will be better able to utilize basic design principles to express their ideas and concerns in the strongest possible visual terms.

Mary Frisbee Johnson

ACKNOWLEDGMENTS

Some of the problems in this book have been circulated casually among artists and teachers for years. I would like to thank all of the people who generously gave me their problem ideas. As far as possible, I have given credit to specific individuals who have devised some of the problems in this book. I apologize to anyone who may have been the original source of a problem in the collection who did not receive proper credit.

The illustrations for the problems in this book were done by first-year, foundations-level students in my Methods and Concepts classes in the Department of Art, Florida State University. The students took these preparatory courses prior to entering upper-level programs in drawing, painting, printmaking, sculpture, photography, film and video, visual communications, fashion design, mass communications, crafts design, art education, and art history.

Very special thanks must go to all of the foundations students that I have taught at Florida State University since 1976. Without their enthusiasm, frank and intelligent criticism, hard work, and excellent solutions, these problems could not have been developed.

TWO-DIMENSIONAL PROBLEMS

T R A S H

PROBLEM:

Solve certain compositional problems through collage using garbage collected in many different kinds of places.

Disposable elements, thrown away and considered to be rubbish by most people, can be very interesting to us as artists. Collected together, throwaway items from a particular place can serve as clues to what happens there. (Think of reporters who search the garbage cans of famous people for information about their lives.) As you move through the activities of your life, begin gathering waste items from the places you visit. Visual scraps from a computer room, for instance, will differ vastly from the leavings of a hair salon. A rodeo will generate a different kind of garbage than will a seafood festival.

Using collaged flat pieces of trash, solve the following compositional problems, using a separate picture plane for each. Work nonobjectively in terms of form, but try to imply a different specific place in each through the use of carefully chosen elements from that place.

1. A symmetrical composition.
2. An asymmetrical composition.
3. A composition with a circular, or centered, motion.
4. A composition with a strong diagonal movement.
5. A composition implying a strong vertical movement using ten or more repetitive forms or elements.
6. A composition that illustrates nonobjectively the motion described by an action verb. The verb should be related to the place described by the garbage elements (a basketball game: run, swerve, bounce; a rodeo: buck, throw, race).

Work with the materials quickly and intuitively. Cut and tear shapes from the collected scraps and move them about on the picture plane, trying differing solutions to each problem before gluing them down. Try to make the richest, most dynamic composition possible. Use each problem as a vehicle for implying a specific place or event by carefully choosing elements of garbage indicative of that place.

Reference

JANIS, HARRIET, AND RUDI BLESH, *Collage: Personalities, Concepts, and Techniques*. Philadelphia: Chilton Book Company, 1967.

Related Artists

Pablo Picasso
Georges Braque
Joseph Cornell
Kurt Schwitters
Henri Matisse
Jean Arp
Idelle Weber
Arthur Dove
Robert Rauschenberg
Richard Hamilton
James Rosenquist
Paul Sarkisian
Juan Gris
Marcel Duchamp
Joan Miró

Max Ernst
Jean Dubuffet
Robert Motherwell

S Y N E R G Y

From a problem by John Stewart.

PROBLEM:

Combine two found photographic images to form a synergistic relationship.

René Magritte did a painting of an apple that filled a room completely, *Chambre d'Écoute (The Listening Room,* 1955). In terms of scale, one is not sure if the apple has become enormous or the room miniscule. These two simple objects combined in an improbable spatial relationship make a much more intriguing image than do either of the objects apart. And that is the nature of synergy: simply, two images that are chosen and put together carefully mean more or become more interesting visually and/or conceptually than they are separately. Images can relate in many ways: in a purely formal sense (juxtaposition of forms, colors, textures, etc.) or conceptually (humor, narrative, satire). There are thousands of possible directions to take in this problem.

The best way to begin is to let images meet by accident. Leaf through all available materials such as photos, magazines, posters, advertisements, postcards, and newspapers, and cut out images that are personally appealing. Starting with large-format color images from obscure sources is generally better than using small photos from a popular magazine such as *People.* Spread the images out on a table, mix them around, and really *look* at accidental relationships. Analyze them in terms of what is eye-catching or unusual; save the ones that are work-able. Start to plug images together deliberately, being careful of poor scale relationships, awkwardly cropped edges, and photos that just lose all meaning or clarity when cut out of their original background or environment. Look for strong, bold images that will make dynamic compositional relationships to each other and to the picture plane. Cut illustration board in the proper size, color, and shape to enhance the combination and glue down the images.

The most important aspect of this problem is exploring many different synergistic relationships and directions and finding the most arresting and absorbing combinations possible. The found image aspect of this medium will present interesting shapes and endless compositional possibilities. Good, clean craftsmanship in cutting and gluing will heighten the visual illusions inherent in the combinations.

Related Artists

Harry Callahan
Salvador Dali
Giorgio De Chirico
Marcel Duchamp
René Magritte
Claes Oldenburg
Meret Oppenheim
Mel Ramos
James Rosenquist
Man Ray
Jerry Uelsman
László Moholy-Nagy

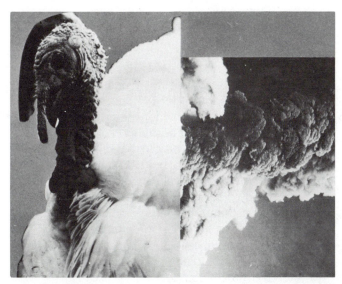

Nancy Polito. Collage.

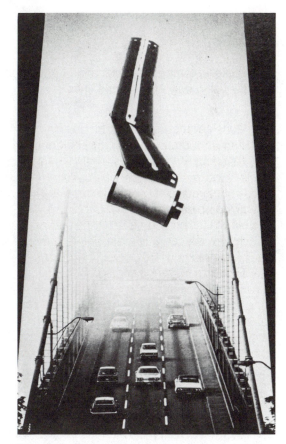

Susan K. Snow. Collage.

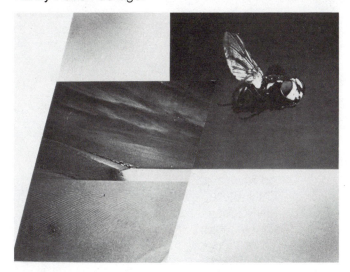

Lee B. Slocum. Collage.

200 STRAIGHT LINES

From a problem by Michael Kellough.

PROBLEM:

Make a composition indicating space nonobjectively using only 200 straight lines.

Consider the definition of the word "line." Look it up in a dictionary, an art book, a geometry text. Think about these questions:

What is a line?
What is a straight line?
What is a point on a line?
How wide can a line get before it makes a shape?
Can a line change width or value within itself?
How long does a line have to be to qualify as a line?
If a line ends at a certain point or runs off the picture plane, does it continue into space conceptually?
Can one use straight lines to make curves?

Use a straight edge and a drawing medium such as pencil, pen and ink, or charcoal. Think about the nature of a line drawn with a fine pen versus that of a line drawn in charcoal. Consider the size of your picture plane to the limitation of using only 200 lines. Work with black lines on white paper or white lines on black. Do not imply recognizable objects or architectural spaces; work completely nonobjectively.

To indicate space, think about overlapping lines and lines that differ in scale, value, texture, and weight. Lighter, thinner lines will appear to be farther away than will heavy, dark lines. The implication of texture can be built up not only by the placement of the lines, but also by varying media. A complete range of values and rhythm can be attained by placing lines closer together or farther apart. Mass and form can be indicated by concentrating lines together; the ending points of lines become critically important. Try to activate the entire picture plane spatially by use of a strong, dynamic composition.

Related Artists

Joseph Albers
Richard Anuszkiewicz
Gene Davis
Nancy Graves
Al Held
Jasper Johns
Sol LeWitt
Piet Mondrian
Ad Reinhardt
Frank Stella
Mark Tobey
Cy Twombley
Victor Vasarely
Agnes Martin
I. Rice Pereira
Barry LeVa

Brad Scherr. Graphite on paper.

PROBLEM:

Working in a two-dimensional medium, try to disguise the image of a common object visually so that it is transformed into something that is not immediately recognizable.

Artists are able to make the ordinary become extraordinary. By synthesizing our perceptions of our surroundings through individual aesthetic sensibilities, we can make highly personal interpretations of the world around us become visual. This problem explores personal perception as well as the nature of abstraction. Abstraction can be defined loosely as the simplification or rearrangement of an objective image so that the immediate communication of a named recognizable object becomes secondary to making an engaging visual statement. This problem also serves as a kind of visual game; with some time, perception, or the help of a clue word or title, the disguised object should eventually become discernible.

Work on a two-dimensional picture plane in any medium. Choose a well-known, common object and think of all the ways in which you can disguise it. The object could be simplified, distorted, or flattened. Details could be sacrificed or certain elements could be exaggerated. Just one portion of the object could fill the space of the picture plane, or the object could be viewed from an unexpected viewpoint or perspective. The object could be fragmented or rearranged in differing ways. A change in color, surface, or texture could effectively change the viewer's recognition of a thing. The style in which the object is drawn or painted could shift our perception of it. The object could be placed in a situation in which it is not commonly found, in which its scale is changed, or in which another element becomes dominant. It could be hidden by camouflage. The object could become more complex through repetition, overlapping, and layering.

Working through the visual elements of abstraction, try to use your personal perceptions and sensibility to make the most interesting visual image possible. Make the actual recognition of the object difficult but not impossible. Explore the possibilities of disguise, paying close attention to all compositional and formal elements and craftsmanship.

Related Artists

Allan D'Arcangelo
Judy Chicago
Christo
Jim Dine
Roy Lichtenstein
Georgia O'Keeffe
Claes Oldenburg
Ed Ruscha
Wayne Thiebaud
Andy Warhol
Tom Wesselmann
Edward Weston
Pablo Picasso
Joseph Raphael

Bruce Blitch. Collage. "Armadillo"

EXPANDED PHOTOGRAPHS

From a problem by Ken Kenniston.

PROBLEM:

Using a variation of the grid system as a basis, interweave two found photographic images by cutting them into pieces and collaging alternate pieces of each to a backboard.

A checkerboard is the simplest possible visual analogy to this problem; think of the red squares as pieces of one photo and the black squares as pieces of the other. By expanding pieces of two images, we can interweave them to obtain a third image with a fragmented, flickering surface. The two images become dependent on each other and can result in a fascinating interplay. Each expanded photo can be seen as a whole by focusing generally on alternate squares. But the photos can also become an abstracted pattern when viewed as a whole. The grid system functions as an ordered vehicle for this interplay of forms.

Collect a variety of found photo images. Shuffle these about, making tentative pairings. Consider how each pair would fit together both conceptually and visually. Look for images that have high contrast in color, value, texture, and complexity. Think about pairing images that relate in subject matter and would harmonize (photos of dancers whose actions could function together both formally and conceptually), or try to find images that would set up opposites (a hot desert landscape versus images of frosty ice cubes). However, the images could also simply be interesting through color and form juxtapositions or even become completely nonobjective when fragmented and recombined.

Make sketches of many different kinds of grid systems. Besides a simple system of squares, a more complex grid could be devised by positioning the grid on a diagonal, using squares or rectangles of varying proportions, dividing a square grid even farther into a system of triangles, or warping the grid visually by rhythmically making the individual grid modules larger or smaller. Decide which kind of grid is most appropriate to your images and make the scale of the system consistent with the size of the expanded photos. Draw the grid on the backs of the photos, number each module in order, and cut the photos into pieces.

On a backboard, glue the photo pieces down in order. The number 1 piece of the first photo should be positioned next to the number 1 piece of the second photo, and so on. The numbered pieces could, of course, start from opposite corners or be positioned in a different system of combination. However, the numbered pieces should be in some kind of order and alternated in this fashion so that both photos are interwoven in their original, though expanded, form.

This problem provides an opportunity to explore your personal interests and perceptions in choosing two photo images that will combine well to form a third. Use a grid system as the compositional basis for tying the two together, using careful craftsmanship to heighten the interwoven illusion.

Related Artists*

Jiri Kolar. *Venus.* 1968.
Tetsu Okuhara. *Winter's Head.* 1971.
Charles McGowen. *Raindrops.* 1970.
Umberto Boccioni
Georges Braque
Charles Demuth
Robert Delaunay
Lyonel Feininger
Juan Gris
Pablo Picasso
Gino Severini
Joseph Stella

*See also artists list for *Metamorphosis* problem.

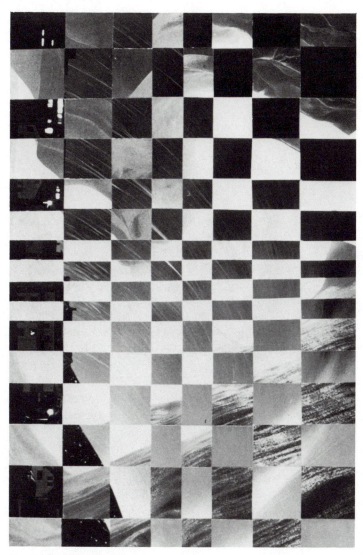

Scott Hamsik. Collage.

Timothy Ward. Collage.

R E P E T I T I O N

PROBLEM:

Make a composition using repetitive copies of the same image.

Find or make at least eight copies of an interesting image. This could be done by obtaining many copies of the same magazine, postcard, or poster or simply by making Xerox copies of a found image. Collage the repetitive images to a supporting backboard.

Repetitive images provide us with the opportunity to explore composition through the use of multiples; there is something inherently fascinating about using duplicates of the same image. The problem is to make these images as interesting as possible compositionally.

There are many directions that can be explored with repetitious images. Repetition especially allows for use of rhythm and movement. By putting images closer together or farther apart, the eye can be made to move faster or slower. Overlapping images imply deep space, as do images that vary in size and value. (Many Xerox machines allow such manipulation.) Images can be distorted by moving them while copies are being made. Xerox copies can be recopied and the image will shrink and become less detailed. Subtle variations of color can be obtained by using a color Xerox and manipulating the color balance controls.

Other variations are made by cutting away parts of the image or fragmenting or rearranging the parts. Other media could be introduced to subtly change texture, color, or value. Some images may combine together and serve as a modular unit within a larger system. Other relating repetitive images could also become part of the composition.

Once the copies are made and cut out, lay them out on a clean sheet of paper and simply play with them, shuffling and intermixing them until a strong composition is attained. Consider all compositional concerns such as balance, harmony, unity, and dominance, as well as symmetry, asymmetry, and directional movement.

The color and value of the supporting backboard is of supreme importance. Images that look lost and vague on a white backboard may gain strength and importance on a darker value. If a color background is desired, be very careful that the color chosen enhances rather than detracts from the repetitive images. Think about the relationship between positive and negative space; cut a backboard of the right size, proportion, and shape to make the figure-ground relationship as strong and dynamic as possible before gluing down the images.

Related Artists*

Richard Anuszkiewicz
Roger Brown
Cynthia Carlson
Joseph Cornell
M. C. Escher
Robert Gordy
Robert Indiana
Jasper Johns
Max Ernst
Joyce Kozloff
Morris Louis
Larry Poons

Bridget Riley
Frank Stella
Wayne Thiebaud
Andy Warhol

*See also artists list for three-dimensional *Bas Relief Repetition* problem and xerography reference books under *Xerox Narrative* problem.

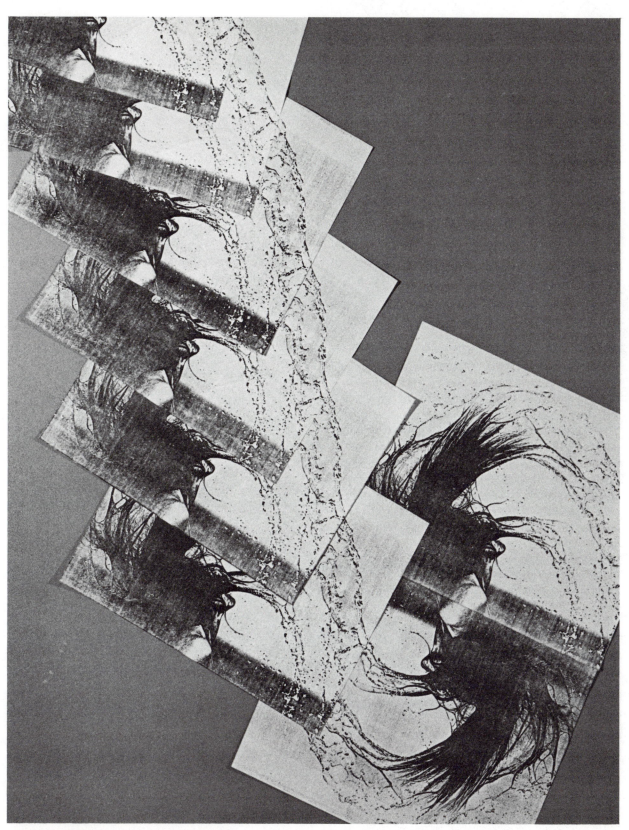

Cynthia Magalian. Xerox image collage.

RUBBINGS

PROBLEM:

Make a composition of repetitive shapes cut out of texture rubbings.

Actual textures are surfaces that have a tactile sense. Implied textures are two-dimensional representations of an actual "feelable" texture. Rubbings are a fast and effective way of transferring a texture onto a two-dimensional surface. A rubbing is made by placing a piece of paper on top of a textured surface and then carefully rubbing something like charcoal, pastel, or graphite across the paper. The high points of the texture are struck by the charcoal and are transferred as a value onto the paper; the low points are left blank, thus implying the underlying texture.

Make a number of rubbings from a variety of textured surfaces. Try different colors, textures, and weights of paper as well as several kinds of rubbing materials. More complex textures can be made by combining more than one color or by shifting the paper slightly after making one rubbing and then rubbing the same surface again. Two textures can also be combined on a single picture plane. Experiment until you are using the right amount of pressure on the paper to produce an even expanse of marks that are a good representation of the texture being rubbed.

At the same time, be thinking about the surface of objects. Try to envision objects with surfaces that are different than those that they have normally. For instance, consider objects with smooth surfaces, such as eggs, whose visual nature would be changed if textured. Change the texture of something to give it new meaning or to change our perception of it. Consider wood-grained clouds, a concrete Mercedes 450SL, a lizard-skinned bathtub. Superimposing a surface texture that in reality does not exist will result in a kind of visual pun.

Draw your chosen object in silhouette or contour form. Cut several of these shapes out of the texture rubbings. Within a repetition of the same object, think about changing the size or viewpoint of the object. The textures could be varied on each silhouette, or the same texture could be used in differing colors or values.

Begin arranging the repetitive shapes on a backboard. (See *Repetition* problem.) Repetition gives us the opportunity to imply rhythm changes and deep space. Value and size changes in the cutouts will imply that objects are closer or farther away, and overlapping elements will also imply depth. Overlapped shapes made of rubbings done on translucent paper will add complexity. Other collage elements may be needed to enhance the cutouts. Plan the composition and collage the rubbings to a backboard with care, aiming for a harmonious and dynamic interaction of all the various parts.

Related Artists

See artists lists for *Repetition* and *Synergy* problems.

Elizabeth Powers. Collage.

Susan Quinn. Collage.

POSTCARDS

PROBLEM:

Use postcards, or the idea of postcards, to make small, mailable pieces of art.

A network of artists in this country and abroad make art that is sent through the mail. Nongallery oriented, the work is highly personal, irreverent, and disposable. The motto of these artists seems to be that "art is not forever." They find cheap ways of printing multiples of images and writings and send the copies out to large numbers of people. They maintain large mailing lists and spend all their money on postage. It is fun getting this stuff in the mail—crumpled, folded, sometimes lost for days—with stamps and post office cancellation marks. It seems to negate the worst aspects of the museum concept and the often absurd overindulgences of the blue-chip investment art world.

Explore the notion of fast, disposable art by making postcards:

1. Buy a variety of existing postcards. Cut them up and collage them back together again. Try to make images relate, or make visual puns and form juxtapositions or repetitions. Put objects into incongruous situations. Just *do* something with them; play with them, use some wit and humor, and see what happens as you work. Then color Xerox them so that the image is on a single picture plane and make the copies into postcards.
2. Make postcards by assuming the identity of an imaginary personality, alter-ego, fantasy hero. Become that personality. Make images and write messages on a postcard as this person would.
3. Use local postcards and draw, paint, or collage images that change the viewers' perceptions of a familiar place. Make something totally unexpected happen in a place that you see everyday.

Work within a group and mail them to members of the group. Collect them again and display them all together. Have fun, be loose, don't get precious about your work—the post office's handling of them can do nothing but add character visually.

Reference

ZACK, DAVID, "An Authentik and Historikal Discourse on the Phenomenon of Mail Art," *Art in America,* 61, no. 1 (January–February 1973), 46–53.

MORGAN, HAL, AND ANDREAS BROWN, *Prairie Fires and Paper Moons*. Boston: David R. Godine, Publisher, Inc., 1981.

FICTIONAL CHARACTER

From a problem by Howard Lerner.

PROBLEM:

Communicate an imaginary persona through two-dimensional mixed-media information based solely upon a found article of clothing.

Have you ever been put on hold on the telephone and idly started reading the phone book for something to do? You begin to ask yourself, who *are* all these people? What are people like who have names like Bubba Gooch, Buffy Hamilton-Whitley, Dirk Strong, or Ossie Beebee?

Or have you been in a Salvation Army store and wondered who on earth wears some of the secondhand items of clothing or shoes on sale there? Consider the following descriptions and try to envision the people who once wore these articles of clothing:

A size 40 polyester sundress patterned with huge pink roses on a yellow-and-green-striped background, with a white vinyl belt and a K-Mart label.

A man's pullover black satin disco shirt, size small, slit to the navel, with five-inch buttoned cuffs and blouson sleeves.

A tie-dyed muslin peasant dress embroidered around the neck with all the astrological signs.

A red-green-black-white plaid sport jacket with incredibly long sleeves.

Begin this problem by looking for an interesting article of clothing that will serve as a clue to the original owner. Look at the size, proportion, purpose, color, fabric, where it was bought, and so on, and expand on these characteristics by giving the person a sex, name, age, nationality, and religion that would seem to be in keeping with the piece of clothing. Make lots of notes on physical appearance and grooming habits. What does your character do all day? Where does the person live? In what kind of house and neighborhood, and in what part of the country?

Give your character a family and friends. Consider the person's political leaning or philosophy of life. What kind of things does the person say? What does the character's voice sound like? What does the person eat? Think about activities, sports, and hobbies. (I am sure that Ossie Beebee raises prize delphiniums and that Bubba Gooch has the biggest four-by-four pickup truck that Chevy makes.) Create a fictional character and devise a life-style and details that originate from your imagination and from the nature of the chosen found object.

Begin to make drawings, Xerox images, photos, writings—anything that will put all this information into two-dimensional visual form. Working on a single picture plane, combine all the character clues into a mixed-media piece. Plan a strong overall composition, and consider all visual elements, such as color, value, harmony, contrast, scale, and image relationships. Use your imagination and perceptions about people to introduce us to a believable character through visual images combined sensitively to make the most complete visual representation possible.

Related Artists

See artists lists for *Biological Relic* and *Found Object Figure* problems.

THREE-IMAGE NARRATIVE

PROBLEM:

Collage together three specifically chosen images in such a way that they become indicative of a well-known story.

The juxtaposition of a knife, a shower curtain, and a nude female would, to any movie buff, immediately bring to mind the climactic murder scene from Alfred Hitchcock's *Psycho.* This film is so well known, that short scene so lauded for cinematic excellence, that these three images are fixed in our minds as the foremost symbols of the story.

By using a skillful combination of elements from almost any commonplace story, you can convey the pith of the narration. By picking key objects, characters, and places that are most important or memorable, you can distill the essence of the piece down to three representative images. Juxtaposed in a sensitive manner, you can develop these symbols into a fascinating art object.

Begin by making a list of the best known books, films, tales, historical anecdotes, stories, jokes, poems, or plays—anything having a narrative content. Choose several that interest you, and try to pick out the three elements that would most strongly exemplify each of them. Then look for corresponding found photos and illustrations, or Xerox, photograph, and draw certain elements yourself. While looking for images, stay open to

images that may accidentally suggest a narrative that did not occur to you. Try to work with large, bold images. Do not use images that tell a complete story already; rather, look for single images that are very specific.

By randomly bringing together the essential narrative information through found images, certain compositional solutions will present themselves as the three images are moved about in differing combinations. Try to use the built-in element of chance to come up with the strongest possible interrelation and mount the images on a backboard of appropriate size, color, and shape.

The point of the problem is not a literal depiction of a particular story, or point in the story, but rather a montage of significant and crucial images. Differences in scale, texture, focus, and style in the found images will result in interactions that can be visually vivid. Through a dynamic melding of the three images, try to use wit and skill in presenting a well-known narrative in a new light. We are concerned visually with a strong overall composition, attention to visual elements such as contrast and harmony, and a wise choice of the three disparate images combined in such a way that they bring to mind the source story.

Related Artists

See artists lists for the *Synergy* and *Xerox Narrative* problems.

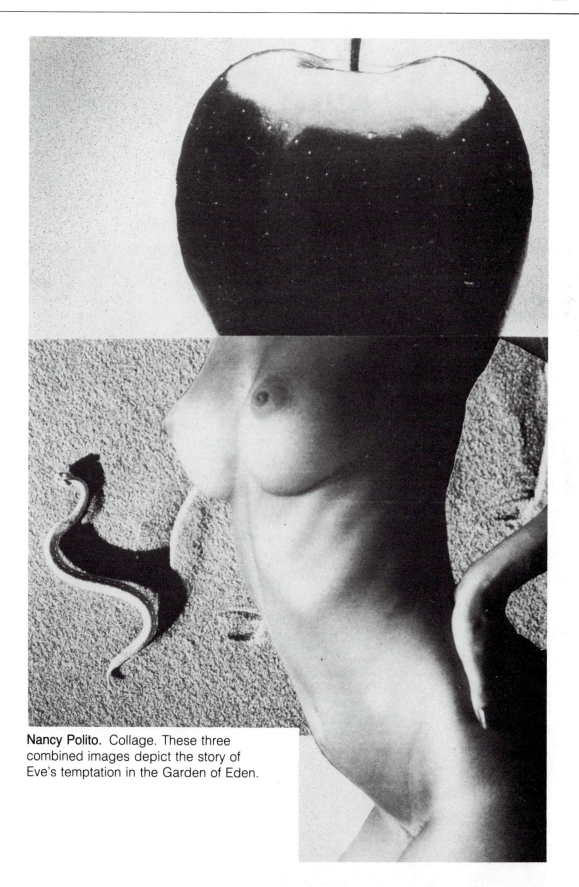

Nancy Polito. Collage. These three combined images depict the story of Eve's temptation in the Garden of Eden.

ENVELOPE

PROBLEM:

Design an envelope that is addressed and relates visually to a specific person or fictional character.

Choose a specific personality as a basis for this problem. Make idea sketches of relating images, objects, places, or people. Try to incorporate these images into the form of an envelope. Let the envelope somehow open or unfold to reveal something on the inside. Address the envelope to the person, and design stamps that relate as well.

Unfold an envelope and look at its construction. Play with scrap paper and work out basic variations using differing shapes. It does not have to be symmetrical or rectangular. (One solution to this problem, addressed to Ray Charles, was shaped like a grand piano.) Think about layering it or allowing it to be opened in successive stages. Try to reveal something new about the person at each step.

In the illustration, we first see the envelope as a rectangle addressed to Clark Kent. The stamps become clue images. As the envelope is unfolded, it forms the shape of a human figure in a business suit and unfolds further to reveal— SUPERMAN!! In this case, the structure of the envelope implies a transformation or change in the person. There are many different directions to explore; try many possibilities and choose the one best suited to the personality you chose.

Use the combination of letter format and the personality of the addressee as a basis for juxtaposing relating images. Use postage stamps, marks made by the post office, addresses, and an unfolding, opening envelope form to enhance the concept. Pay special attention to the choice of images as well as to all formal elements such as rendering, composition, and careful craftsmanship to make the piece relate to a specific source person.

Related Artists

See artists list for *Biographical Relic* problem.

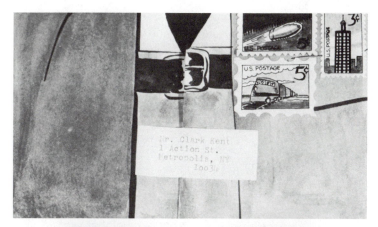

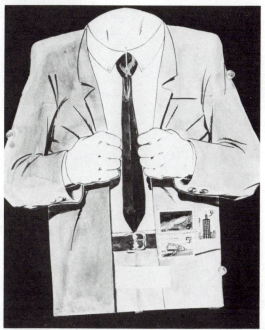

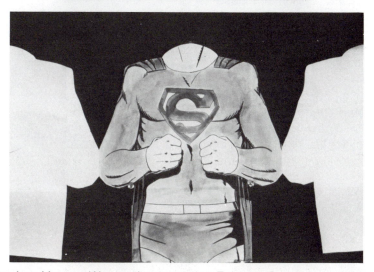

Stephen Vance. Watercolor on paper. Fold-out Superman envelope.

M A P S

PROBLEM:

Make a map to get lost.

RITUAL: Start with a map, any kind of map. Think about the logic of its purpose. Now do something to it to deliberately negate its function: cut it up, switch the pieces around, glue it back together, combine it with drawings, photos, charts, diagrams, symbols, pieces of paper from the streets. Cut holes in it. *Shoot* holes in it. Tape it, mask it, tear it, shred it, fold it, crumple it, leave it out in the rain. Confuse it, run over it, Xerox it, fragment it, sleep with it, obscure it, cloud it, camouflage it. Write on it. Draw and paint on it: pencil, ball-point pen, felt-tips, spray paint, motor oil, purée of carrots, finger paint, ink, charcoal, lipstick, blood, pastels. Add places to it: atolls, mountains, clouds and sky, stars and Mars, weather, heaven.

This is about magic and intuition and looseness and illogic and enigma and mystery. Don't worry about formal visual concerns. Make it a ritual; a ceremonial act; a personalized, formal action.

IMAGE: Now bring it on back. Look and feel and think about what you did, how you felt when you were doing it. Start with new maps and materials, or reuse portions of the first ritual effort. Now do it again, this time controlling it. Pick out parts of the ritual that worked visually; try to keep that looseness. Write about what happened. Plan it now, based on what happened before. Learn from the first part; do it again and pull it all together and polish it with intuition, heightened perception, and attention to composition and formal elements.

References

The meteorologist on TV
Atlases and globes
NASA satellite maps
Topographical maps
Marine and flight charts
Road maps
Geography books, geology texts
Astronomy charts

ONO, YOKO, *Grapefruit*. New York: Simon & Schuster, Inc., 1964.

Related Artists

Christo
Douglas Huebler
Jasper Johns
Dennis Oppenheim
Robert Smithson
Robert Wade
William T. Wiley

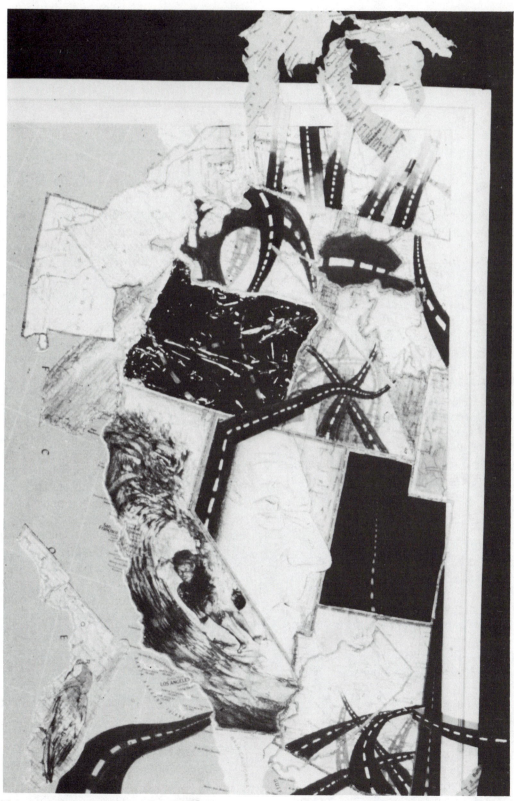

Meg Monahan. Collage, mixed media.

SOUND PATTERN

PROBLEM:

Construct a complex, continuous, overall pattern using forms derived from sound.

Certain adjectives can be applied to both sound and visual concepts. Dull, soft, sharp, rhythmic are all words that can be both audio and visual adjectives. Sound can thus become a source for deriving form. By listening carefully to various sounds, a visual image can be evoked through drawing. Make shapes and lines that *look* like specific noises *sound*.

Listen carefully, to begin with, to isolated, single noises. Try to analyze their qualities. Listen to continuous sounds next. How do these differ from a single, finished sound? Consider the difference between the slam of a door and the squeak of a passing bicycle wheel. The former is an emphatic one-shot deal. It has qualities of finality and anger, a big sound, dull, but full bodied. The latter is a continuous sound, high in pitch, irritating, whining, sharp, and linear. The trick is to draw these sounds, and their descriptive characteristics, in nonobjective form. We are not interested in drawing either the door or the bicycle, but rather in concentrating on the quality of the sound and how, with our intuition and aesthetic, to best express that quality visually. Trying to transcend the barriers of your individual senses, make idea sketches of these sounds and how they look to you.

Now try combining the shapes or lines in some kind of rhythmic repetitious pattern. Make all possible analogies between the nature of sound and visual vocabulary. What color is a scream? What texture is the sound of a car starting on a freezing morning? Using a variety of media, try layering the sound forms within a picture plane. Try to imply space; interweave, overlap the forms. Try scale changes and spatial differences.

Listen to music and separate out the sounds of each of the instruments, the genre of the music, the varying rhythms. Make visual representations of each kind of sound, and try to interweave them again, approximating the same kind of feel that the music has. This may help in combining six or seven different sounds together.

Within the pattern, try for variety. Some sounds may be chunky, others sinuously linear. One of my students described a rounded, organic, rich-green shape as the essential sound of the woods; a sharp, brown, angular line was a twig snapping, disturbing his peace. Various other kinds of forms darted throughout the picture plane, and he became very irritated with me when I failed to recognize immediately what he described as "a bird whistle with a tail."

Of primary concern in this problem is that your final piece feel sound-derived. The finished pattern should be composed of varied eccentric elements, implying space and setting up a continuous field pattern. An exploration of many different kinds of media is implicit; smooth gouache, for example, may be better suited to the nature of certain sounds than rough charcoal. Attention must be paid to depiction of space, composition, scale of elements, color, and texture to translate the characteristics of sounds as vividly as possible to visual terms.

Related Artists

Pat Adams
Billy Al Bengston
Gene Davis
Stuart Davis
Jean Dubuffet
Al Held
Wassily Kandinsky
Joan Miró
Judy Pfaff

Lucas Samaras
George Sugarman
Jackson Pollack
Piet Mondrian
Victor Vasarely
William Baziotes
Matta
Edvard Munch.
The Scream. 1893.

Bruce Blitch. Collage, mixed media.

Theresa Thompson. Collage, mixed media.

Kimberly Cavanagh. Mixed media.

Lisa Carraretto. Collage, mixed media.

PROBLEM:

Use a variety of two-dimensional media to make a rebus that illustrates a well-known phrase or saying.

A rebus is a humorous puzzle or riddle made up of symbols, pictures, letters, and numbers that represent the sound of certain words and syllables. The puzzle is read by sounding out or speaking the names of the images and combining them with the connective letters and symbols to decipher the message represented. For instance, a picture of a bumble bee in combination with a plus sign and the numeral "4" would be read as *before*. In our language, words that sound alike often have different spellings and meanings. Therefore, to illustrate the word "count," a picture of a cow can be used in combination with the letters *nt* because, when spoken, the images sound like the intended word. Thus the rebus becomes a kind of visual game of charades.

Sometimes a word can be broken down into many symbols; others may need to be illustrated by a single straightforward image. The word "flag," for instance, may be illustrated best with a picture of itself. Occasionally, words can be presented in a more obscure way if the viewer has been primed with fairly easy clues to the rest of the phrase. In the example, the word "thoughts" has been illustrated by Xeroxes of Rodin's *The Thinker* interwoven with abstract forms resembling the speech-thought balloons found in comic strips. Thus, the word "thoughts" can be recognized by the viewer within the context of the rest of the phrase, *"A penny for your . . ."*. It is not enough simply to represent the word, but to try to symbolize it in the wittiest, most imaginative, way possible.

Begin by making lists of common phrases. Make sketches of all the possible ways of illustrating the words in the phrases. Choose one that is long enough and complex enough to generate a large variety and number of symbols and images; make sure that it is rich in possibilities for *interesting* images. Generally, try to break up the space on a picture plane into a strong composition of smaller areas that will contain each word; working on graph paper may be helpful. The symbols and images must be made to flow in a logical way so that the viewer can decipher the message. Use collage, drawings, type or lettering, stencils, rubber stamps, and so on to begin illustrating the words in rebus form.

Remember that as working artists we are concerned with making the richest possible visual images without necessarily being constrained by the traditional cartoon simplicity of most rebus puzzles. Think carefully about the composition as a whole, including the relationship of elements in a particular word to each other and the placement of the word area within the picture plane. Try to maintain witty and original illustrations without making them so cryptic that the communicative intent becomes incomprehensible to your viewer.

Related Artists*

Marcel Duchamp
Öyvind Fahlström
Ed Ruscha
René Magritte

*See also artists list for *Visual Pun* problem.

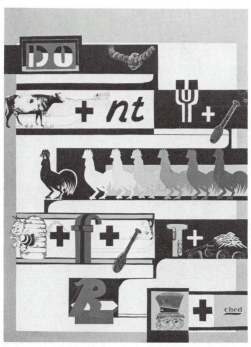

Katherine Speed. Collage, mixed media. "Don't count your chickens till they're hatched."

Thomas A. Mangan. Collage, mixed media. "A penny for your thoughts."

XEROX NARRATIVE

PROBLEM:

Tell a simple animated story in ten or more steps by making copies of objects placed on the glass of a Xerox machine.

A Xerox machine can be thought of as a big, crude camera. Objects can be photographed by placing them on the copy glass, and a feeling of animation can be achieved by moving the objects slightly from copy to copy.

A *narrative* is a story, either fictitious or true. A story can be told visually as well as verbally. In this problem, the plot will unfold in a series of Xerox copies that function like individual frames of a movie. Movement is implied by the placement of objects in differing positions from the copy before. As in any narrative, it is necessary to plan a simple plot and an ending. One student bought several different kinds of cookies and took them to the copy center. She began her narrative with dense, ordered patterns of cookies. Gradually, they began to shift and disintegrate. Occasionally, a grasping, greedy hand, or a chewing mouth, would appear. At the end of the series, only small scattered piles of cookie crumbs were left.

Begin by looking at small common objects in your living space, or while shopping or walking about, and try to picture the object doing something, or moving. Think of the inherent visual characteristics of objects as well as their functions and relationships to each other. Because the machine focuses on the glass plate, stick to relatively shallow objects. Remember that everything will have to be placed upside down for the machine to copy things as they are to be seen.

Once an object is chosen and the narrative is planned, start copying and look at each sheet in relation to the one before to make sure that the visual leap from copy to copy is not too wide for the viewer to follow. Use a smooth, even motion with changes in visual rhythm for plot changes, climaxes, and other elements of the story.

The finished copies can be displayed as books, or as animated flip books, on the wall in a long connected line, or they may be mounted in a grid system reading left to right like a comic book. The copies could be filmed and actually made into an animation or photographed as slides and shown with a dissolve-unit projector.

The narrative aspect of this problem is of supreme concern; be a good storyteller and don't bore your audience. Try to understand motion as it applies to the gradual and smooth changes in an animated sequence. Make sure that the narrative makes sense from frame to frame. The glass of the Xerox machine must be thought of as the picture plane; consideration must be paid to the relationship of the objects to each other and to the edges of the glass. Plan the narrative ahead so that the images will function well compositionally in relation to the story and the movement desired. Think about all formal elements such as contrast, value, color, texture, and the size and shape of the finished copy.

References

McCRAY, MARILYN, *Electroworks*. Rochester, N.Y.: International Museum of Photography at George Eastman House, 1979.

FIRPO, PATRICK, LESTER ALEXANDER, AND CLAUDIA KATAYANAGI, *Copyart*. New York: Horseguard Lane Productions, Ltd. for Richard Marek Publishers, 1978.

Related Artists

Terry Allen
Eleanor Antin
Dottie Attie
Les Crims
Robert Heineken

Duane Michaels
Sonia Sheridan
Alexis Smith
Eve Sonneman

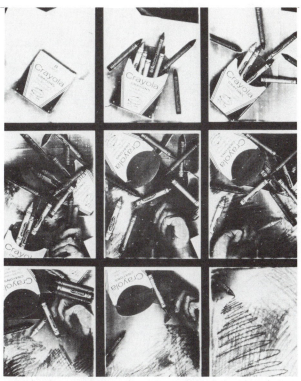

Sally Fox. Xerox copies and crayon.

Anita K. Fleet. Xerox copies.

ZOETROPE

PROBLEM:

Make an animated sequence appropriate for use with a zoetrope.

A zoetrope is a moving-picture device that was invented around 1824. This simple rotating cylindrical device contains a sequence of still images on the inside that, when looked at through a series of slits, make the image seem to move. This device is a precursor to motion picture film and uses the same visual-optical principles.

Zoetropes can be built in any number of sizes, but a small one that will fit well on a stereo turntable (which provides rotation) can be based on the following specifications:

Begin with a long strip of flexible but strong black paper. It should be approximately 4″ wide; the length is determined by the desired number of sequential image cells. Twenty image cells will make a satisfactory animation. The viewing slits are cut in the top half of the strip and should be ¹/₈″ wide and cut lengthwise 1″ apart. The image cells should also be 1″ wide and fit in the lower half of the strip, falling between the slits cut in the top half. When the ends of the strip are fastened together, a cylinder is formed (containing the images on the inside) that will sit on top of the turntable.

Design an animated looped sequence of about twenty images. This must be a continuous circular animation so that the first image on the strip flows naturally back into the last image when the strip ends are fastened together.

The crude nature of this kind of simple animation will not allow for fine detail. Working in any medium, design simple, clear, sequential images that connect smoothly to imply continuous motion when the zoetrope is spinning. To do this, simply let the image move slightly from panel to panel; when in motion, the images will be moving fast enough that the slight change of position will be seen to flow smoothly. It may be best to work on a separate picture plane(s) and glue the images down to the black paper strip when they are finished.

Place the cylinder containing the images on a turntable. Position yourself so that you can look at an angle through the moving slits at the images passing by on the opposite side of the cylinder. Spin the turntable by hand, or try varying automatic speeds to determine the best velocity for viewing the sequence. The faster the turntable spins, the faster the images will seem to move. If each image is planned carefully in relation to the next, a smoothly animated moving-picture sequence should be perceived.

References

BOHN, THOMAS W., AND RICHARD STROMGREN, *Light and Shadows*, pp. 6–7. Port Washington, N.Y.: Alfred Publishing Co., Inc., 1975.

FINCH, CHRISTOPHER, *The Art of Walt Disney*. New York: Harry N. Abrams, Inc., 1973.

MACDONNELL, KEVIN, *Eadweard Muybridge: The Man Who Invented the Moving Picture*. Boston: Little, Brown, and Co., 1972.

MONACO, JAMES, *How to Read a Film*, p. 55. New York: Oxford University Press, 1977.

ROBINSON, DAVID, *The History of World Cinema*, pp. 10–11. New York: Stein & Day Publishers, 1974.

Related Artists

Giacoma Balla
Umberto Boccioni
Marcel Duchamp
Thomas Eakins

E. J. Marey
Eadweard Muybridge
Gino Severini

Top: Thomas A. Mangan; Bottom: Bruce Blitch. Zoetrope strips showing the sequence of continuous images before being shaped into a circle.

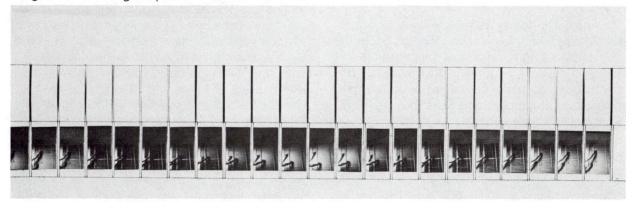

Brad Scherr. A zoetrope strip showing the sequence of continuous images before being shaped into a circle.

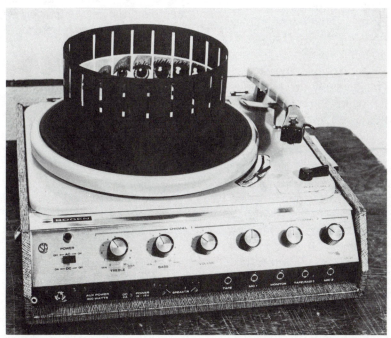

Thomas A. Mangan. A zoetrope strip placed on a turntable that will provide rotation and motion.

METAMORPHOSIS

PROBLEM:

Lay out a grid system, eight squares across and six down, on a large sheet of graph paper. In each horizontal strip, make an object image metamorphose square by square into a completely different object. Illustrate the same metamorphosis across each of the horizontal rows, but use a different medium, style, or technique in each.

A metamorphosis is a gradual change, alteration, or transformation. In this problem, start with an image and gradually, square by square, transform it into something else. The first and last squares of each horizontal row will illustrate the two principle images; the six squares in between will contain images conveying the transformation. The same metamorphosis will be used in each of the six horizontal rows, but, by using a different medium, style, technique, color or value range, each vertical row will have variety even though the same essential information is repeated.

Make lists of objects and images. Draw them in varying ways. Try pairing objects together and analyze the possibilities for an interesting relationship. Make extensive idea sketches of these ideas and polish them until a metamorphosis between two of the objects begins to make sense. Then begin working on the graph paper grid, thinking about how to best make each of the six strips disparate from the others. This may involve using several types of media or simply trying many different styles done in the same medium.

Metamorphosis offers possibilities for pure abstraction of form. An object can simply change its shape gradually until it becomes, is transformed into, the second image. Or it could follow a more narrative line, much like an animation in which an object moves through a space while telling a simple story and begins to interact with other objects. Try to place your images in some kind of place or space, and think about light sources that provide shadows and highlights. The visual jump from square to square must be smooth, even, and followable. Consider using color or value, as well as movement and form-change, to help the viewer move logically through the eight-square strip.

The compositional basis for this problem is the grid system. Within this static organization, try making the overall picture plane harmonious and complete as well as making each individual frame interesting and each horizontal strip continuous.

Reference

LAYBOURNE, KIT, *The Animation Book*. New York: Crown Publishers, Inc., 1979.

Related Artists

GRID SYSTEM:
Jennifer Bartlett
Chuck Close
Jasper Johns
Sol LeWitt
Agnes Martin
Piet Mondrian
Paul Sharrits
Andy Warhol

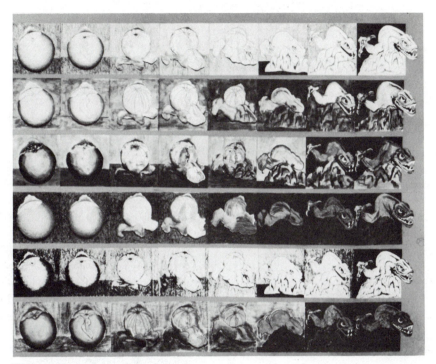

Michele Guimond. Mixed media.

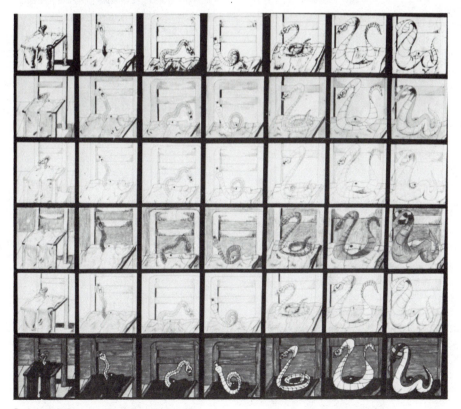

Carey McNamara. Mixed media.

OBJECT-WORD VARIATIONS

PROBLEM:

Use at least eight horizontal, repetitive image bands in a wide range of two-dimensional media and styles to illustrate clues, variations, and definitions of a single word image.

List all the ways of thinking about a particular word image that interests you. For example, the word "cowboy" could be thought of in many ways:

VARIATIONS: Horseman, cowpuncher, good guy/sheriff, bad guy/bandit, gunslinger, rodeo rider, hero (the Lone Ranger and Tonto), movie star (John Wayne), rancher.

RELATED IMAGES: Cowgirl, Indian, horse, boots and spurs, ten-gallon hat, lariat, cactus, bandana, saddle and bridle, star/badge, school marm, stagecoach, pickup truck, chawin' tocacco, posse, noose.

PLACES AND SPACES: Desert, mountain, range, roundup, bunkhouse, jail, corral and barn, honky-tonk and saloon, rodeo, Boot Hill.

PHRASES AND WORDS:
"Home, home on the range . . ."
"WANTED: Dead or Alive."
"He died with his boots on."
"Giddyap." "Yup." "Nope."

RELATED ACTIVITIES: Listen to country music and cowboy songs, go to Western movies, watch reruns of "Bonanza," wear boots, ride a mechanical bull, visit a rodeo, eat beans and drink boiled coffee for a week.

Make similar lists for several images. Using the one with the best potential for variation, pick out at least eight images that will clearly yet diversely illustrate the word object.

Experiment with the widest possible variety of two-dimensional media; paint, drawing materials, paper collage, found images, photos, rubber stamps, stencils, graphic-arts materials, transfer lettering. Each of the eight bands will be done in a different style or medium. Each contains one visual image repeated several times. (See *Repetition* problem.) At least one of the lines should be related words, either a phrase or repeated words, and attention must be paid to typographical design. It may be easiest to work on each line separately and, after trying them in differing orders, glue them to a larger sheet of illustration board. However, with some compositional planning, the images can be worked directly on the backboard.

The images used to illustrate the subject matter must be chosen and executed to make the finished piece rich, solid, complex, and intriguing to the viewer. In a way it is a puzzle; each line serves as a definition of the original word name. No matter what stylistic mood is set (tongue-in-cheek clever; misty-eyed nostalgic), each image must serve to provide a clue to the implied original word without literally spelling it out.

The eight lines must be put together with sensitivity to spacing, rhythm, density, color, value, and texture to make the picture plane as a whole compositionally and visually strong.

References

HART, HAROLD H., ed., *The Great Giant Swipe File*. New York: Hart Publishing, Inc., 1978.

MILLER, JONI K., AND LOWRY THOMPSON, *The Rubber Stamp Album*. New York: Workman Publishing, 1978.

Related Artists*

SERIAL IMAGERY AND IMAGE VARIATIONS

Andy Warhol	Roy Lichtenstein
Les Crims	Claes Oldenburg
Georgia O'Keeffe	Tom Wesselmann
Jasper Johns	Judy Chicago
Claude Monet	Jim Dine
Frank Stella	Robert Indiana

*See also artists list for *Repetition* problem.

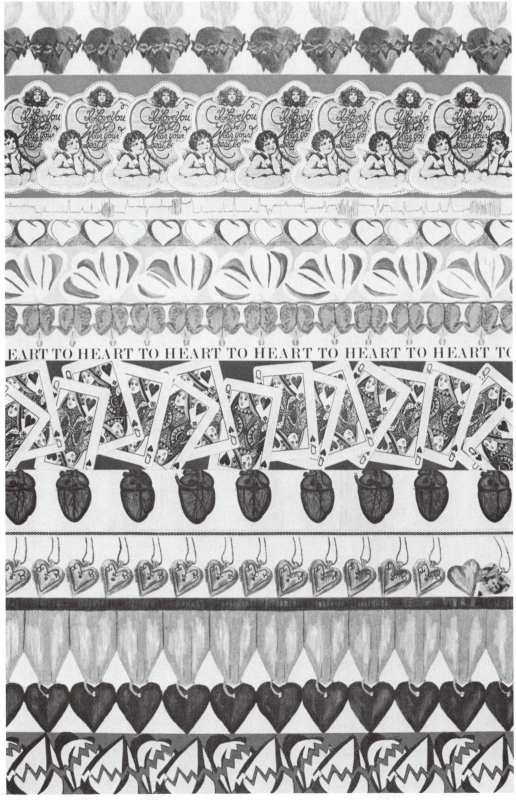

Betsy Eichelberger. Mixed media.

CIRCULAR NARRATIVE

PROBLEM:

Working with a group of artists who have been assigned random words as source material, design a continuous circular sequence of narrative images.

1. Two batches of slips of paper containing words must be prepared. One batch contains nouns (objects), the other adjectives. Each person in the group draws one of each. The combination of the two words determines each individual's basic source image.

2. An alphabetical list based on the names of the people in the group is drawn up, and each person's adjective and noun are listed after their name. This list determines the narrative sequence of the final piece and group members must adhere to this order. Here is one such list:

frightened	camera
fragmented	airplane
pierced	revolver
shattered	submarine
nervous	bridge
folded	skateboard
penetrating	sandwich
icey	trenchcoat
electric	ball of string
hairy	pickle
glittery	tongue
worn-out	salamander
stuffed	frisbee
pneumatic	egg beater
distorted	snake
angular	armadillo
scaley	vacuum cleaner
mutilated	moon
crushed	motorcycle
powerful	blimp
sensuous	ray gun
gridded	spaceship

3. Each artist will prepare a panel of a standard size and format containing at least seven squares set out in horizontal form, much like a comic strip. The panels will eventually be joined together linearly to make one long piece. (Suggested size: $3^1/_2$″ by $3^1/_2$″ squares laid out $^1/_2$″ apart on the panel, with $^1/_2$″ top and bottom borders. The space at the end of each panel should be only $^1/_4$″ wide as, when the panels are linked together, they will combine to make the standard $^1/_2$″ separation.)

4. Each artist must consult with the person before and after on the list to conceive a narrative that not only will enable each individual to incorporate the assigned word image but will also make conceptual and visual sense in joining each person's image to the next. (The last person on the list will consult with the first person, thus completing the cycle.) The subject matter of each panel is determined by the word image, and how these images can be made into a continuous story is decided by the people whose images are juxtaposed.

5. These panels can be done in any medium once the basic story line is set. Artists whose pieces connect together can make general decisions regarding color, value, or composition of the abutting

panels to make disparate rendering styles and media changes less jarring as well as to enhance the narrative flow.

6. The individual panels are then mounted on a wall in an unbroken horizontal line, connected together. In a small room, the panels could move all around the four walls, so that the last image joins up with the first, thus creating a continuous narrative that may be entered into at any point and that advances smoothly to the right, around the room, back to the beginning point.

Begin by letting the two drawn words, adjective and noun, bring images to mind. Be aware of all definitions and connotations of the words. Think about how the adjective affects the object. Make idea sketches of all varieties of images that come to mind. Discuss the ideas with the person

before and after you on the list, and plan to move the viewer through the narrative sequence in a way that makes visual sense.

While trying to think of ways of connecting these disparate images, loosen up and remember that as artists we can make totally fanciful and magical transformations, metamorphoses, and storylines. The most outrageous or impossible things may happen to draw two differing images together. Each individual square, however, must move smoothly and logically into the next, so that a flow and rhythm is maintained throughout the whole piece.

Related Artists

See artists lists for the following problems: *Zoetrope, Xerox Narrative, Metamorphosis,* and *Object-Word Variations.*

Group project. For the purpose of this illustration, four individual student solutions to the Circular Narrative problem have been stacked vertically instead of being connected together in a continuous line. These four, picked out from a larger continuous narrative, illustrate the words "savage chair," "soft clock," "stony meatball," and "cracked garden." Notice that in each individual panel, the assigned word/image is illustrated while somehow narratively connecting with the next panel.

CLUE DIPTYCH

PROBLEM:

Create a before-and-after situation using two separate panels on a single picture plane.

Certain combinations of places, objects, and times of the day become fraught with narrative possibilities. Jerry Tallmer, in the *Village Voice,* describes a Maya Deren film, *Meshes in the Afternoon:* "There is a girl in it, and a door, and a key, and a flower, and a knife, and an empty house; and a turning phonograph in the empty house, a telephone off the hook; and a flight of stairs down to a sidewalk, and on that sidewalk a woman in black whose face is a mirror . . .".*

This description, with its combination of mysterious elements, surely brings to life a situation of anticipation. Keeping this example in mind, begin to think about places. Consider each place as a potential setting. It could be a landscape, a kitchen, an elevator. Think of the objects, elements, and people occupying that space. Devise a story in your mind involving these elements. Try to make the situation as provocative to the viewer as possible.

Using this situation, we are not interested in depicting a specific action or story within the space. Rather, we want to imply, through a change from the first panel of the diptych to the second, some kind of narrative action, motion, time lapse, or rearrangement. It is necessary to set up a convincing situation in the first panel. In the second, something should have transpired, with the viewer left with only the clues, or aftermath, of that activity.

Thinking over your choices of elements and places, try to use the anticipation of a juicy situa-

tion to conceptualize various prospects for action. Then try to envision the clues that would be left after the episode. Think about what the clues imply and the questions that will be raised in the minds of the viewer: Why is the garden burned to a crisp? Who left the red cowboy hat floating in the pool? Why is nothing visible out the taxi windows but endless expanses of water?

Consider carefully the observer's position in the situation. Move within your imaginary space like a movie camera, considering views of the same situation from differing angles, zeroing in on significant portions of the space, or pulling away for a wider view, distorting the viewpoint or perspective. Any kind of two-dimensional medium can be used. Whether using a camera, paint, or a drawing medium, it is necessary to think about how visual concerns such as composition, perspective, color, rendering style, and so on will enhance the particular images and mood you wish to create.

This problem opens up many possibilities for human response. As artists, we can play with enigma, mystery, and absence of logic. Time can pass, violence can occur, inanimate objects can take on a life of their own. Anything is likely to happen. Explore the possibilities of manipulating visual clues, of leaving a gap in time, of skipping the action part of a narrative, leaving out the actual event. The picture plane is magic; one can represent, through what is left unsaid, some kind of narrative incident and at the same time involve the viewer in an emotional response.

Related Artists

Roland Reiss
Robert Graham
Edward Hopper
George Segal
Terry Allen

Andrew Wyeth
Richard Estes
Raphael Ferrer
Sandy Skoglund

*Jerry Tallmer, "Maya Deren: Hymns at Heaven's Gate," *Village Voice,* January 14–20, 1981, p. 41.

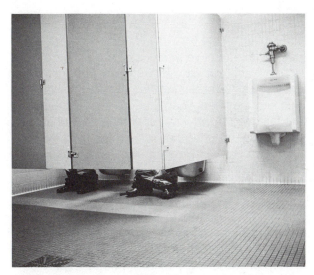

David Partelow. Photograph.

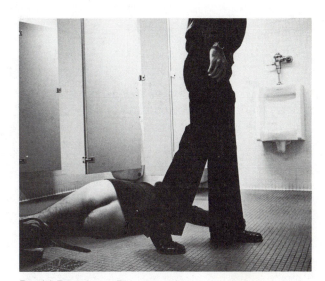

David Partelow. Photograph.

Elizabeth MacLean. Colored pencil.

STRATA

From a problem by Ron Milhoan.

PROBLEM:

Using at least five sheets of paper stacked together, tear or cut away portions of each to reveal parts of the undermost layers.

Begin by thinking about things that have layers or strata; consider levels of archeological digs, geological earth strata, rings in a tree trunk. Each layer in these situations reveals information about a past time and provides knowledge about events that happened long ago. This stratification is not only informative but often is very beautiful visually as well.

Our goal in this problem is to work reductively, that is, to remove parts of a prepared picture plane to reveal other layers of visual information. This functions as a kind of backward collage; rather than gluing down positive shapes to make a composition, we will be taking away shapes (making actual negative space) and successively revealing underlying strata.

Work on at least five separate sheets of paper, all the same size. Do something completely different to each sheet, working totally nonobjectively. Try for variance in color, value, texture, pattern, shapes, marks, media, surface, kinds of paper. Stack the sheets in differing orders, thinking about which sheet is most appropriate on top, which should come second, and so forth.

There are two basic methods of working on the layered sheets. The first is to stack the sheets together and staple or tape them down firmly to a backboard along all the edges. Then begin tearing or cutting areas of the top sheet away, literally digging your way down to successive sheets. Consider what is thus revealed beneath and begin removing parts of the second sheet in relation to the first and so on, until the bottom sheet is finally seen. (Besides cutting or tearing, think of alternate ways of making holes such as shooting, burning, punching, gouging, etc.) The other method is to remove portions of each separate picture plane and try differing combinations of the loose sheets. When a satisfactory composition is reached, the sheets can then be stacked together and fastened down to a supporting backboard. In either case, watch the growing, changing relationship between the layers carefully and manipulate and plan your movements accordingly. Work directly with your materials; do not do sketches or plans. Try to work intuitively and loosely, while analyzing the visual qualities of what is gradually being revealed.

The exploration of reductive rather than additive processes is the most important aspect of this problem. It is necessary to plan the visual nature of each layer carefully before beginning, and then use perception and thoughtful choices to directly remove parts of one sheet to reveal another. This problem provides the opportunity of exploring a complex, almost sculptural, process as well; try to make an intriguing single picture plane from the revealed strata of many different elements.

Reference

VON SCHAEWEN, DEIDI, *Walls*. New York: Pantheon Books, 1977.

Related Artists

PAINTERS:	EARTHWORKS/ARCHEOLOGY:
Rafael Ferrer	Joseph Beuys
Peter Saari	Nancy Graves
Antoni Tapies	Michael Heizer
	Gordon Matta-Clark
PAPERWORKS:	Mary Miss
Billy Al Bengston	Dennis Oppenheim
Sam Francis	Charles Simmons
Kenneth Noland	Robert Smithson
Michelle Stuart	
Beth Ames Swartz	
Jo Zucker	

David K. Manley. Mixed media.

Bruce Blitch. Mixed media.

TIME CAPSULE

PROBLEM:

Make a layered montage of images and words that give a sense of a particular time and place in history.

A time capsule is usually thought of as a container of some sort that preserves records or objects that represent a culture at a particular point in time. This problem, done in three separate layers, should function much like a time capsule. Through the careful combination of words and images, a sense of a particular era of history or a specific culture can be evoked.

First, choose a particular time and place in the past that interests you. Make lists of people, places, events, and objects representative of that era. This could be a very personal exploration (your family's farm in Illinois when it was first settled in the nineteenth century) or go in a wide, general direction (Egypt, during the reign of Tutankhamen, 1358 B.C.). List appropriate words and phrases that will communicate something about the era chosen. Assemble found images, Xeroxes, photos, drawings, maps, or illustrations. Work with all these ideas and images on three different pictures planes of the same size.

BOTTOM LAYER: On a sheet of illustration board, lay out a structured grid system of words and phrases, symbols or numbers, relevant to the period of history chosen. Use dry-transfer lettering in an appropriate type style, stencils, calligraphy, your own handwriting, or cutout words from printed matter. Try to make the division of space within the grid system as powerful as possible, as this will be an ordered basis for other looser, more organic images and shapes.

MIDDLE LAYER: Collage the collected visual elements onto a sheet of acetate. Arrange them in such a way that the composition works with and reveals parts of the underlying word structure when the acetate sheet is placed on top of the bottom sheet of illustration board.

TOP LAYER: On a second sheet of acetate, use transparent media such as inks, markers, or graphic arts film to make simple silhouettes or forms that relate conceptually to the historical data and visually enhance and tie together the other two layers when placed on top. This transparency permits more complexity of images and color while allowing the information on the other two sheets to show through.

Fasten the two acetate sheets to the backboard at the top, letting the sheets hang free so that the viewer can pick up and look at each individual layer, or let them fall together smoothly to form a more complex whole.

This problem explores a particular era of history as a basis for the conceptualization of imagery that is not only engaging visually but communicative of some kind of information as well. Attention should be paid to making the visual elements enhance the feeling or mood of the culture and time chosen. Each sheet should be as strong as possible visually; at the same time, these three layers of completely different information should combine to make a complex and complete final piece.

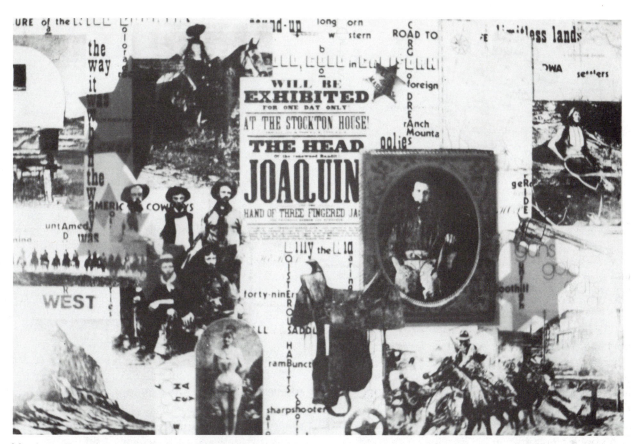

Monique Rosasco. Mixed media collage on acetate and illustration board.

Liza Beth Crunk. Mixed media collage on acetate and illustration board.

TRANSPARENT LAYERING

PROBLEM:

Superimpose three square sheets of transparent acetate of the same size containing images and relating typography. Present them in such a way that it is possible to rearrange the sheets easily into differing combinations to make a great variety of visual images.

The transparent media in this problem allow us the means of coming up with a staggering 3,072 different visual possibilities. (Each square of acetate can be turned so that any edge can be read as the top, each transparent sheet can be looked at from either side, and the three sheets can be layered in differing orders.) The ability to look *through* an image into other images and the ease with which these can be switched about provides the artist with a random and accidental element that makes the problem an engaging visual game.

Begin by experimenting with media. There are many kinds of acetate: frosted, matte surface, wet media, colored, and differing weights. Try transparent and translucent media on the acetate: ink, watercolor, felt-tips, graphic arts self-adhesive color and texture films, and photofilm. Try opaque media as well: collage, ink, transfer lettering, acetate pencils, grease markers, and acryllic or cel-animation paint. Make sketches or try things on pieces of scrap acetate. Think about four-sided, reversible composition and how to take advantage of this aspect of the problem and make it work when all the sheets are juxtaposed.

Choose a simple word image as the basis of the problem. One student used the image of an owl, which in turn suggested the environment of the woods at night as a related image. The Latin name of the owl became part of the information as well. Make one sheet of acetate words, planning the typography so that the sheet will communicate something however it is turned. Another sheet should consist of images that illustrate or relate to the words. Make the last sheet enhance and tie together the word sheet and the image sheet. Take advantage of the fact that something entirely different can be presented when a sheet of acetate is turned over. Consider that more colors will be formed when transparent color layers overlap. Think about using opaque elements; opacity eclipses underlying images, so plan accordingly.

Present the three sheets together in a clean, well-lighted environment so that the viewer might easily play with rearranging the sheets. They could be presented in a shadow box structure or on a backboard hanging from pegs; whatever is done, make sure that rearranging the sheets is made easy and simple.

Try to get the most visual mileage out of the three sheets, the most disparate compositions possible. Handling the materials as well as possible, make sure that every combination will prove interesting. Using a triple, overlapping, transparent picture plane should result in a rich and spatially complex image. This kind of thinking can then be carried to work done on a single, fixed picture plane.

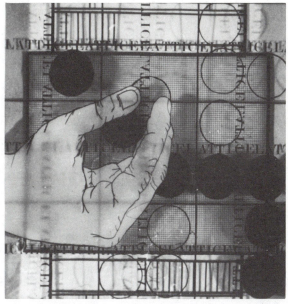

Betsy Eichelberger. Sheets are layered and held in place in a wood box.

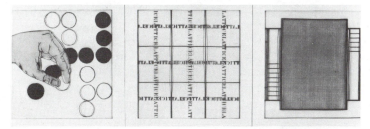

Betsy Eichelberger. Mixed media on acetate. Open state.

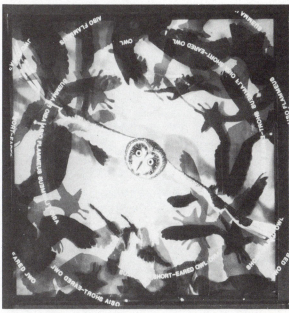

Lee B. Slocum. Graphic arts film, dry-transfer lettering on acetate. Open state.

Lee B. Slocum. Sheets are layered and held in place in a wood box.

COLOR PROBLEMS

BOX PAINTING

From a problem by Jeff McGinnis.

PROBLEM:

Make a painting derived from the surface of a box that has been painted in a random, arbitrary fashion.

This problem begins as a group effort. Each artist in the group starts with a shoe box. Cut a hole large enough to put your hand in the side, and tape the lid down. Every person in the group works on all the boxes. Using a large variety of two-dimensional media, work blind inside the box, making marks or brushstrokes on the surfaces. Each box is worked on in this deliberately random fashion until everyone in the group has done something to all the boxes.

Open up the boxes and flatten them out. Let them dry. Cut a hole in a piece of paper approximately 1″ by 2″, or 1½″ by 1½″. Place the piece of paper over the flattened box. Move it about, letting the worked surface show through the hole. Look for an interesting and dynamic composition of brushstrokes and marks as you move the paper about. Pay attention to color combinations and textural differences as well as to interesting form and spatial juxtapositions. When you have zeroed in on an area that particularly interests you, tape the sheet of paper down to the box so that you don't lose it.

The information left showing through the cut-out square or rectangle is the basis of the painting. Blow this area up at least twenty times onto a sheet of illustration board. Grid the basic information from the small area up onto the board in light pencil, and begin to work in a simple water-solu-ble medium such as gouache, tempera, or acrylic. (See *Pointillism Portrait* for grid information.)

The fascination of this problem lies in what begins to happen when a tiny area of imagery becomes much larger. Minute shapes become huge, slight textures become coarse, small areas of intense color become knockout when saturating an area twenty times larger than the original. Although your source imagery was done with absolutely no planning, your choice of a particular cropped area to paint is obviously of crucial importance. Look carefully at the nature of the marks made. A line drawn with pastel will be very different from a blob made with enamel. Begin to plan how, stylistically, the information should be rendered. Your choices run the gamut from hard-edged, flat, paint-by-number forms to intensively blended brushwork.

You must match the color—hue, value, and intensity—in your small piece exactly on the large painting. Make sure that the color relationships are strong when choosing an area to paint. Much can be learned about color mixture by having to deliberately match specific source colors.

Related Artists

Clyfford Still	Lee Krasner
Willem DeKooning	Jasper Johns
Hans Hoffman	Robert Rauschenberg
Helen Frankenthaler	Robert Motherwell
Jackson Pollack	Mark Rothko
Richard Diebenkorn	Joan Mitchell
Franz Kline	

See Color Plate 1.

COLOR-ALTERED OBJECT

From a problem by Janice Hartwell.

PROBLEM:

Change the color of an actual object so that your perception of that object is changed or altered.

How would you react if you woke up one morning and the sky weren't blue, but a dazzling emerald green? What if you went to a funeral and everyone there was wearing brilliant colors and the hearse was bright yellow? Would you be confused if you drove up to a stop sign and it were green instead of red? Or if a stop light had three shades of blue instead of the traditional red, yellow, green?

Certain colors have the power to evoke emotional and psychological responses in people. Colors symbolize and communicate particular messages and kinds of information. Individual response to color can be a delicate, memory-oriented process. Cultural customs and traditions affect color response as well. Color psychology has become an important, fascinating field that analyzes the relationship between human response and color.

We expect to see specific kinds of color in certain situations. We also have symbolic responses to the colors of objects. One solution to this problem involved having a nurse come into the room in a totally gray uniform—cap, dress, stockings, and shoes. Our reaction, when we had been expecting sparkling white, was typical—we did not want to be cared for by a nurse in a uniform that was not indicative of cleanliness.

Use human response and the psychological aspects of color to change your perception of a given thing. We are not interested in manipulating form or surface, but just the color of an object. Look around you as you move through the activities of your day and make note of all the things that are defined by color. You can explore your personal reactions to color (I know a person who finds it impossible to drink milk from a blue-tinted glass), but the choice of your final object and color change should be based on more universal concerns.

Choose an object and think about what color could change it. Objects such as chairs and books and telephones come in so many colors that are purely decorative that changing the color would make no impression on your viewer. Make sure that you choose an object whose meaning or function will truly be altered by a color shift. You could paint an actual three-dimensional object or, if you are interested in portraying something huge that must be seen in a particular situation (the moon, the Golden Gate Bridge), you could work with some kind of two-dimensional representation or manipulated found image.

The kinds of lessons learned from this activity, as well as exploring color psychology a little further, can then be applied to a personal art-making process. An aware and intelligent manipulation of color within a painting or sculpture will heighten a particular mood or feeling and help to elicit the desired visual and emotional response from the viewer.

VIBRATION

From a problem by Janice Hartwell.

PROBLEM:

Plan a continuous interlocking pattern painted in two complementary colors that will illustrate the optical principle of perceived vibration.

Every hue color has a complementary color directly opposite it on the color wheel. In every pair, one color is warm (fire, sun colors), and the other is cool (water, ice colors). When two complementary colors of the same intensity are juxtaposed in a specific way, they seem to vibrate or set up a visual push-pull effect. We will illustrate and heighten this optical phenomenon by using two complementary colors in an interlocking pattern.

A checkerboard or a pattern of alternating stripes of the same width are good examples of interlocking patterns. In a field pattern of this nature, there is no distinction between negative and positive space. That is to say, if you focus on the red parts of a checkerboard, they appear to be red squares on a black background. But if you focus on the black squares, they become black shapes on a red background. Therefore, there is no set figure-ground relationship as our eyes tend to push or pull alternate colors in and out of the picture plane. This back-and-forth seeking of positive-negative space will enhance the inherent qualities of vibration in the complementary color relationship.

Begin devising an interlocking pattern by making small drawings of recognizable objects. Cut silhouette shapes of one of the objects out of paper and place these in alternating fashion like the red squares on a checkerboard onto the tabletop. Begin to look at the space that is left *between* the surrounding repetitive shapes and see if it suggests another objective image. (Remember finding the shapes of ships or faces in floating clouds when you were a kid?) Look at the shape sideways and upside down. Redraw and change both shapes until they begin to lock to-

gether. Or work from relating images (a horse-head and cowboy boots, a scuba diver and sharks) and manipulate the viewpoint and shapes of these objects until they fit together like a jigsaw puzzle, the contour of one shape forming the contour of the other. (Don't forget that, although the *shapes* will be different, *they must occupy the same amount of space.*)

Lay the pattern out on illustration board and begin painting the images. Make a flat surface with clean defined edges in a matte medium such as gouache or tempera. (The problem could also be solved by collaging shapes cut out of Color-Aid paper.) Experiment with color combinations. You could use complementary colors such as red and green, or orange and blue, or approximate complements such as red and blue-green, or orange and blue-violet. Be sure that you have tested the combination beforehand. Look at color combinations under different light sources. Two colors that do absolutely nothing under fluorescent lighting may go crazy when placed in direct sunlight.

The scale of your images to the size of the picture plane is very important. Make the images fairly small to heighten the vibration set up by the complementary colors and the nature of interlocking patterns. Use these elements in combination with witty and engaging object-image renderings to create an interesting spatial relationship and an engaging optical illusion.

Reference

ALBERS, JOSEF, *Interaction of Color*. New Haven, Conn.: Yale University Press, 1963.

Related Artists

Gene Davis	Bridget Riley
M. C. Escher	Larry Poons
Richard Anuszkiewicz	Jules Olitsky
Victor Vasarely	

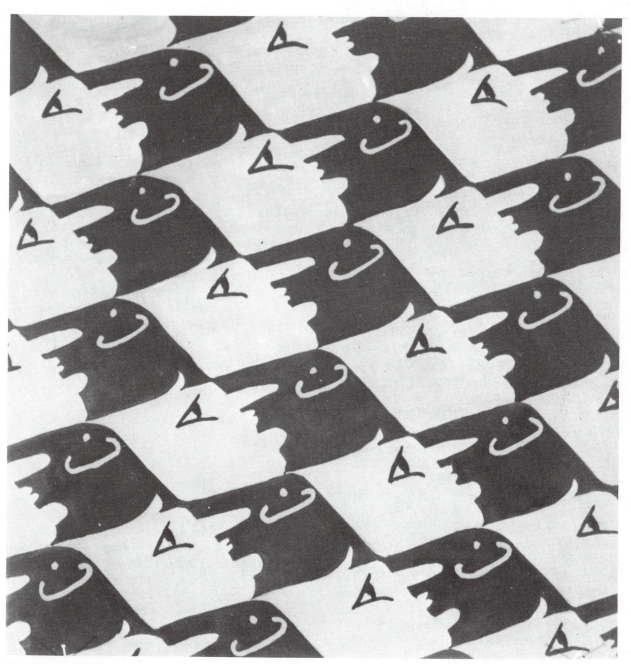

Elizabeth Lois Strauss. Gouache.

COLOR THEORY GAME

From a problem by Janice Hartwell.

PROBLEM:

Design and build a playable game that somehow uses the principles of color theory both as a visual source and as a basis for the playing rules.

This problem is actually a sneaky way of ensuring that you know and understand the basic principles and vocabulary of color theory. It provides the basis for conceptualizing and constructing a game that is not only entertaining but also becomes an interesting, well-designed visual object.

It is essential that you study a good color theory or design book and familiarize yourself with basic color rules. I've never felt that it is necessary to make an intensive study of color systems or color optics; a more intuitive approach to the use of color in the art-making process is preferable. But any artist must understand how to arrive at the colors needed in his or her work. You must know what primary colors are, how secondary and tertiary colors are made from primaries, how to change the value and intensity of a color, how color in pigments differ from color in light, how basic color psychology and symbolism work. Use these basic principles to conceptualize the rules for your game.

Your game could be a board game or a three-dimensional object. It could be simple, oriented toward small children, or be very complex. You could devise a plan for an electronic or video game; a game that requires a high level of technology could be presented in proposal form.

Whatever the form of your game, the rules must be developed along the lines of the nature of color. For example, a point system could be devised based on color intensity and value. Intense colors could be worth more than dull colors within a scoring system. Power plays could be set up; dark colors could overpower light colors. Players could be penalized if their colored marker lands on a space that is the complement of that color. Elements of the game colored in tertiary colors could be rarer or more valuable than primary colors.

One elegant solution to this problem involved a triple, stacked playing board of clear plexiglas. Transparent color forms were laid out on each board and the markers were in transparent colors as well. Markers could be moved about the boards at all three levels, and the game was played by looking through the top board into the information presented in the lower boards. The rules were based on the color combinations created when the layered colors blended to make other colors. The beauty of the object made it a pleasure to play; the complexity of the rules and the fascination of using the different color combinations made it a game that was consistently fun to play.

Explore many ideas in sketch form; polish the best of these through drawings. Work the rules out so that they are playable and logical in relation to the visual design of the game. Make the game involving and fun to play. (One solution to this problem, an incredibly complex chesslike game, is so interesting to play that a major toy company is considering buying the rights to it.) Use your knowledge of all formal visual elements and craftsmanship to make the best-designed game possible.

Reference

Games magazine

COLOR SLIDES

PROBLEM:

Make a short slide presentation that explores color as it applies to light.

We perceive things as being a particular color because of the way in which light illuminates them, setting up a complex communication between our eyes and our minds. The principles of color applied to pigments (painting and drawing media) is very different from color-light processes. For example, we know that if we mix together the three primaries (red, yellow, blue) in paint, we get a neutral, or gray, color. But if we project the three primary colors of light (red, blue, green) onto a screen, this will result in white, or all light. Consult a good color theory book (see Bibliography) for further explanation of the relationship between light and color.

We will begin to explore color in light using slides and a slide projector. Begin by purchasing blank slide mounts at a photographic supply store and gathering together transparent materials such as acetate, mylar, felt-tipped markers, inks, watercolors, and graphic arts color and texture films that have sticky backs. Make your own slides by working on the transparent surfaces of the acetate or mylar with the transparent media and mounting the images in the slide mounts. You could also work with actual photo slides or negatives as well. (Check the garbage cans outside of photo labs for scrap film and throwaway images that may be interesting for you to explore). Consider scratching the surface of the photo emulsion or combining a photo image with other media. Several layers of information could be combined into one slide mount for added complexity or richness. Consider using some opaque materials such as India ink or typewriter white-out that will block the light in selected areas.

Your slide presentation must involve an exploration of color relationships, color systems, or color theory. It could be a purely formal presentation of nonobjective form and color relationships, or it could imply a narrative, animation, or metamorphosis. The slides could combine found images with drawn and painted images. They could be controlled tightly, or they could allow an element of chance or randomness to become a factor in your presentation.

Work with at least two projectors so that images can be superimposed or overlapped on the screen. Put the timers on the projectors on automatic; see what happens when images overlap in different combinations. It is important that you somehow explore the transparent qualities of light and what happens when two or three colors begin to combine together. Use a dissolve unit that attaches to the projectors and allows alternate images to fade and blend into each other. We used four projectors that allowed many images to combine and overlap on the projection screen.

When we had viewed all the individual presentations done as solutions to this problem, we threw all the slides into a box, mixed them up, and loaded them at random in four slide carriers. Then we turned on the projectors and allowed the automatic timers to move, shift, and combine all the images together at random.

Much can be learned about color relationships from both activities in this problem. Doing a slide show like this will provide you with some practical experience with light and color that can then be applied to the light processes found in photography, film, and video. Make good use of color, all elements of visual vocabulary, and the choice and arrangement of your slides to make your presentation as interesting and informative as possible.

Related Artists

See artists lists and references for *Xerox Narrative*, *Zoetrope*, *Metamorphosis*, and *Video Sequence* problems.

STENCILS

PROBLEM:

Use stencils and spray paint to make a composition of overlapping, layered shapes.

One day I was working in my studio spray painting some cutout sculptural forms laid out on a sheet of newspaper. When they were dry, I turned them over and painted the other side a different color. When the forms were removed, they left beautiful blank and overlapping shapes on the newspaper, defined by the sprayed color around them. Negative shapes made in this fashion and left in a field of sprayed color illustrate one way of using stencils to make form on a two-dimensional surface. The other is done by cutting shapes out of a sheet of paper and spraying positive shapes through the hole that is left. This problem involves the use of both negative and positive stencils.

We are interested in working with stencils to build up a complexity of overlapping and layered form. Begin by looking for objects that have interesting contours. Try laying them on a sheet of paper and spraying them. Lift the object up and analyze the visual qualities of the shapes that are left. Try cutting shapes out of paper or illustration board and spraying through the shapes left in the picture plane. (Of course, you can also stencil by spraying around the cutout form.) Begin to think about how these negative and positive shapes could interact.

With just a general idea of how this interaction could work, begin spraying your chosen images onto your final picture plane. It is our intention in this problem to work by allowing the piece to grow as you work, letting the interesting things that happen accidentally with a medium such as

spray paint become part of your piece. Do something; observe the results; then do something else in relationship to the first action. Really *look* at what is beginning to develop after each step. Be flexible and ready to change your thinking as the piece evolves. Use your knowledge of composition to make intelligent placement decisions.

Spray paint allows us to make the paint surface very sparse and transparent as well as opaque and dense. Try to use both elements for contrast. Using several colors will become interesting as dots sprayed in the same area begin to blend together optically to form other colors. Blended and overlapped shapes will add richness and complexity and give a sense of layered, transparent-translucent depth.

There are several ways in which to spray paint: you can use cans of aerosol paint, an old pump spray bottle filled with paint, or a toothbrush that will splatter dots of color when you run your thumb across the bristles. Try both opaque paints such as enamel or acryllic and transparent media such as inks or watercolor. Think about the color of your base picture plane; it will greatly affect transparent color as well as show through the sprayed images. Also consider the surface of the picture plane; dots of sprayed color will stay crisp on a hard surface and will spread and grow softer on a porous material.

Sooner or later, in building a complex layering, you will have to make the decision to stop. Look carefully at each step of development, and use your judgment and intuition in deciding when the colors, forms, and compositional elements have fallen together to make a strong and complete piece.

See Color Plate 2.

PROBLEM:

Make a painting that combines four disparate ways of looking at a single object image as subject matter, done in four different painting styles and four specific color systems.

Someone once called this the end-all-be-all color/painting problem. It's true that it's complicated, so you'll need to pay close attention to the instructions.

Begin by looking for four different found color images that represent varieties of the same object. Use photographs or images found in books, magazines, cataloges, postcards, and posters, for example. Solutions that became interesting visually have ranged from using an object as simple as a tomato to one as complex as a pinball machine. The images should be truly varied; look for differences in viewpoint or perspective, scale, composition, environment and related images, as well as varieties of the object itself.

Begin making drawings of how these four images could be combined together on a single picture plane. Try overlapping or interweaving, set up some kind of formal spatial division of space, or work with the images much more loosely to fit together in a more organic fashion.

Grid the images up onto a larger sheet of illustration board, drawing the basic information from the found images lightly in pencil. It may be necessary to use a different grid proportion for each image as your source materials will come in disparate sizes. (See *Pointillism Portrait* for grid information.)

Using the given color in each of the found image sources, solve each of the following color problems:

Translate the values of the color in the first image into corresponding values of black, white, and grays.

Translate the color of the second image into corresponding values—tints and shades—of just one hue, making a monochromatic color scheme.

Translate the color of the third image into matching values and intensities of the direct complement of each color. (Black stays black; white translates as white.)

Match exactly the color found in the fourth image.

Begin painting, using gouache, tempera, or acryllic on illustration board. Use test strips, a good color wheel, a value chart, and a package of Color-Aid color sample sheets to help you translate the necessary information in each problem.

While painting, use a different style in each of the four images. You may need to do some test paintings to make the four completely disparate and separate. You could try a pointillist technique, color washes, hard-edged flat simplification of shapes, painterly brushstrokes, and so on.

We are attempting to combine all this various information to make the most interesting overall painting possible as well as to learn more about handling paint and mixing and using color. Certain aspects of the problem can work for you to tie this information together. Composition is the most important connective element. Thinking ahead and figuring out which images would best solve each of the color problems will allow you to plan much of the overall color in advance. The choice of color in the monochromatic problem obviously should be made on the basis of what seems to be needed to make the other color images relate. Try to use the problem to present fresh and new ways of looking at your subject matter, presented in a strong and innovative compositional structure.

See Color Plates 5 and 6.

Plate 1. **Roberta Wilmering.** Gouache. *(See "Box Painting" problem, p. 48)*

Plate 2. **Julie A. Olsen.** Spray paint. *(See "Stencils" problem, p. 54)*

Plate 3. **Elizabeth Lois Strauss.** Gouache. "Pablo Picasso" *(See "Portraits" problem, p. 56)*

Plate 4. **Susan L. Smith.** Gouache. "Georgia O'Keefe" *(See "Portraits" problem, p. 56)*

Plate 5. **Sherolyn Sisco.** Gouache. *(See "Four of Everything" problem, p. 57)*

Plate 6. Brad Scherr. Gouache. *(See "Four of Everything" problem, p. 57)*

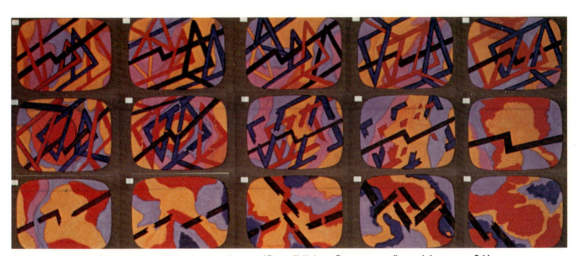

Plate 7. Nancy Bluestein. Felt-tip markers. *(See "Video Sequence" problem, p. 61)*

Plate 8. Sherolyn Sisco. Tempera. *(See "Video Sequence" problem, p. 61)*

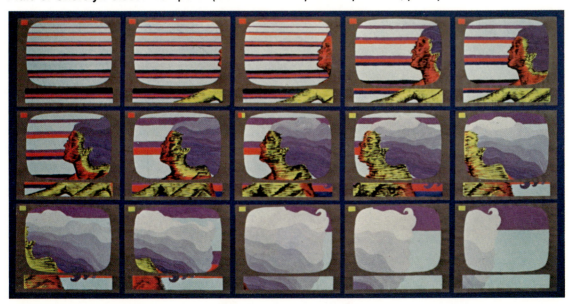

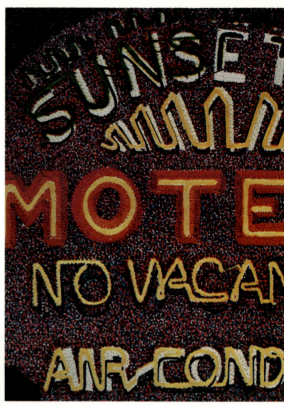

Plate 9. **Mark Cecil.** Gouache. *(See "Word-Image Combination" problem, p. 64)*

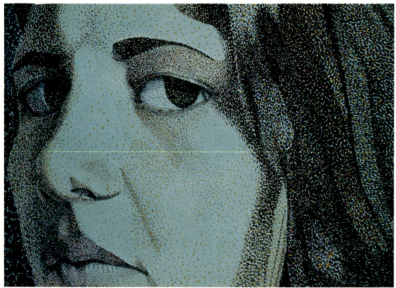

Plate 10. **Jan Shade.** Gouache. *(See "Neon" problem, p. 65)*

Plate 11. **Robin Russo.** Gouache. *(See "Pointillist Self-Portrait" problem, p. 66)*

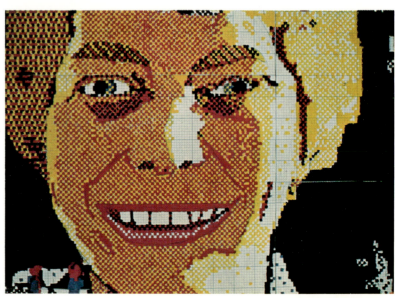

Plate 12. **Tim Copeland.** Gouache. *(See "Pointillist Self-Portrait" problem, p. 66)*

Plate 13. **Stephen Vance.** Tempera, enamel. *(See "Bad Color" problem, p. 68)*

Plate 14. **Michael Boyles.** Tempera. *(See "Bad Color" problem, p. 68)*

Plate 15. **Diana M. Van Doren.** Tempera. *(See "Bad Color" problem, p. 68)*

Plate 16. **David K. Manley.** Gouache. From James Clavell's *Shōgun. (See "Literary Source" problem, p. 70)*

Plate 17. **Elizabeth MacLean.** Gouache. *(See "Literary Source" problem, p. 70)*

Plate 18. **David Philip Swartz.** Gouache. *(See "Word List Painting" problem, p. 71)*

Plate 19. **Krisse M. Pasternack.** Gouache. *(See "Word List Painting" problem, p. 71)*

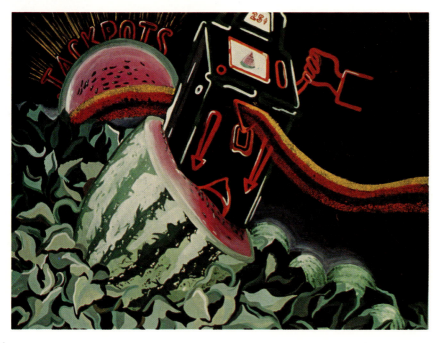

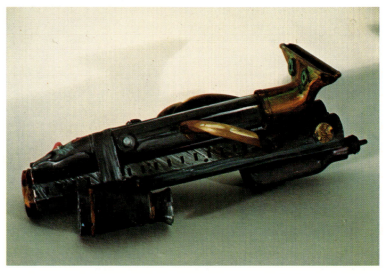

Plate 20. Elizabeth Newkirk. Gouache. Assigned word: "Diner" *(See "Object/Place Illustration" problem, p. 72)*

Plate 21. Karen Kelly Keltner. Gouache. Assigned word: "Slot Machine" *(See "Object/Place Illustration" problem, p. 72)*

Plate 22. Meg Monahan. Found objects, acrylic. "Found-object Starship" *(See "Robots, Starships, and UFO's" problem, p. 74)*

Plate 23. Cheryl Adger. Gouache, contac paper, found object. *(See "Camouflage" problem, p. 75)*

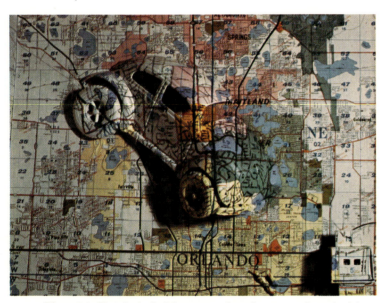

Plate 24. Frank J. Caldarazzo. Acrylic, map, found object. *(See "Camouflage" problem, p. 75)*

Plate 25. Michael Boyles. Slide projected upon three-dimensional forms of plaster bandage and Xerox copies of photo-booth photographs. *(See "Self-Portrait" problem, p. 138)*

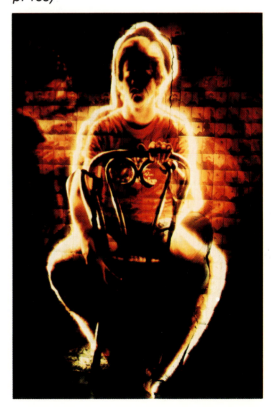

PORTRAITS

PROBLEM:

Paint a portrait of a famous person that translates the color found in a photographic image into a complementary color scheme.

When this problem was being researched, it was near the end of 1979. We decided to do portraits of important people of the 1970s, a kind of time capsule of the decade. Everyone worked on the same-sized illustration board in gouache or tempera, and about fifty portraits were combined to make a huge gridded piece on the wall. You can solve this problem individually or you can work within a group to make a larger piece. There are many ways of combining well-known people together in a group; you could paint famous people of a particular year, or break it down into more specific areas such as famous artists, famous women through history, movie stars, and so on.

Begin by choosing a well-known person who interests you or is a hero or heroine to you. Find a large, well-defined color photo of the person that concentrates on the head and shoulders. Cut it out from its surrounding background. Steep yourself in the person's life story and accomplishments. Look for color images that are separate from the portrait and that become indicative of some aspect of the person. Collage this information onto a sheet of paper and superimpose the portrait in the foreground. Use the entire picture plane, making sure that the person fills a large portion of the image and is the major, most dominant feature. The background information could be a montage of relating images, a specific place, an episode from the person's life, or abstract or nonobjective forms that could communicate a mood or feeling related to the person.

Grid the collage information onto a sheet of illustration board in pencil. (See *Pointillism Portrait* for gridding information.) Begin painting in gouache or tempera. Lay in general areas of color first, and gradually build up detail. Photo images contain continuous-tone values; these are value changes that blend smoothly from light to dark. This could be translated by breaking down a particular shape into smaller hard-edged shapes of systematic value changes that our eyes read as an indication of value change and image contour. The other extreme would involve intensive blending and brushwork.

Translate all the colors in the photograph into their direct complements in paint, matching intensity and value. For example, a green area on the collage will translate into a red area in the painting, as red is the complement of green. Dull green would become dull red; light blue-green would become light red-orange. Black translates as black; white as white. But remember that black and white can also have touches of warm and cool color. If a black area reads as a warm black, translate it into a cool black by mixing it with blue or violet or green.

Use a piece of paper with a small hole cut in it laid on top of the collage to isolate a particular color area and help you to see it separately from the colors around it. Use a pack of Color-Aid paper, a value chart, and a good color wheel as aids in determining complements in paint mixtures.

This problem will make you use less literal color, which will help you to learn about color mixture, light and shadow, and values and intensities of color, resulting in interesting and rich color combinations that you may not have discovered on your own. The portraits will take on a very strange quality as skin tones become very cool in nature. Use the most dynamic compositional relationship between the large portrait and the background images. Make the relating images communicative of that person, relevant, and interesting. Use these elements, as well as the color limitations, to make an engaging total portrait of a particular well-known person. At this point, the portraits could be combined together or be seen as separate pieces complete in themselves.

Reference

FELDMAN, EDMUND BURKE, *Varieties of Visual Experience*, pp. 283–296. Englewood Cliffs, N.J.: Prentice-Hall, Inc., 1973.

Related Artists

Alex Katz	Francis Bacon
Andy Warhol	Tom Wesselmann
Chuck Close	Lucas Samaras
Alice Neel	Richard Lindner
David Hockney	Mel Ramos
Ed Pashke	Alfred Leslie
Phillip Pearlstein	Diane Arbus

See Color Plates 3 and 4.

LICENSE PLATES

PROBLEM:

Design and render a new license plate format for a particular state in America.

A grubby van filled with broken Kleenex boxes and cranky kids passes through Tampa on a scorching Florida afternoon. The van, as well as the Porsche passing it, is carrying Montana license plates. Spying each other's matching plates 3,000 miles from home, the occupants of the cars honk and wave, and for a moment they are transported into cool breezes and piney mountain air. Later, they run into each other in the parking lot of the Sarasota McDonald's and have a lively and friendly conversation, even though they probably wouldn't have given each other the time of day back home.

For driving America, the license plate is a common visual source of communication. The basic function of license plates is the legal identification of a vehicle. Typical of most government designs, they are dull and uniform, even though some states have made an attempt to use interesting color or a symbol or a phrase to replace the common "prison made."

License plates could become better designed and even more evocative of a particular place. A kind of traveling minibillboard, license plates could better promote aspects of a particular place while giving travelers some art to look at on the Interstate. It would be terrific if state governments would commission some license plate art or sponsor license plate design contests.

Begin the problem by picking a state you know well, or one that you've always wanted to visit. Make lists of things associated with the state such as geographical references, flora and fauna, famous people and sights, well-known symbols. Do sketches of these things; add phrases, sayings, songs, poems, and the like. Think about the essential differences in places; New York brings

to mind different imagery than does New Mexico. Remember to look at negative aspects of a particular place or problems that are found there. The plate could carry some kind of political or social or ecological statement as well.

Narrow down these ideas and work on ways of communicating your concepts. Try to push the format of the plate in new directions. Plates are usually 6″ by 12″ rectangles; could that shape be changed? Does it have to be metal? Could it be done with full-color photo images? Could the typography be changed? Could it have moving parts or light up? Think about all these aspects, remembering that, whatever you do, the plate still has to be able to be read by a bad-tempered, fast-moving highway cop.

This is also a rendering problem. Paint the plate life size, mounted on a car or truck. Crop in on the plate and show some of the surrounding vehicle.

Render the plate to communicate materials, surface, embossing, light sources, and so on. Or actually make a sculptural license plate and mount it on a vehicle, where it could be photographed.

The primary purpose of this problem is to improve on the design of existing license plates, making them more interesting aesthetically within existing governmental regulations. Another purpose is to use visual symbols and images and words to communicate regional differences and a sense of a particular place. Render the metal, plastic, paint, raised surfaces, decals, and words found in license plates, as well as part of the vehicle on which the plate is mounted. Pay attention to all visual elements such as composition, color, painting style, and craftsmanship to make an interesting painted image as well.

Related Artists

See artists list for *Machine* problem.

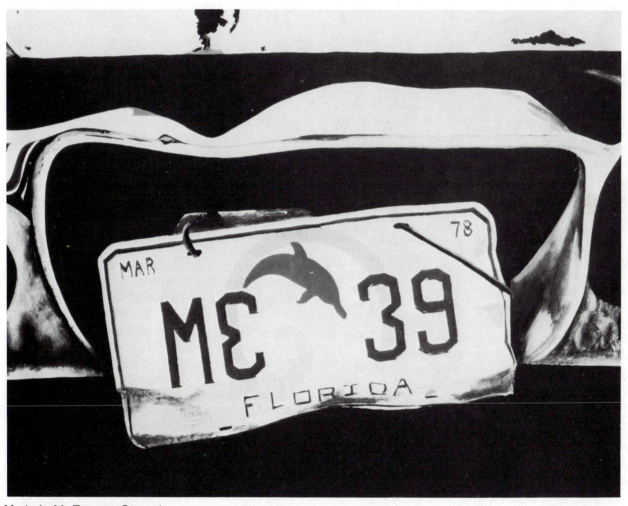

Marjorie M. Emery. Gouache.

AFTERIMAGE OBJECTS

PROBLEM:

Put two identical found objects side by side; paint repetitive relating images onto the surface of the first object so that we perceive afterimages on the white-painted surface of the second.

Afterimage is a perception phenomenon described and illustrated best in Josef Albers' *Interaction of Color.* In one example, he invites us to stare intently at a red circle in a black background and then switch our gaze quickly to a white circle in a black background. Most people will perceive the white circle to be green or blue-green, the complementary color of red, for a short time. Similarly, when most people look at a pattern of yellow circles on a white background and then move their eyes to stare at a blank white sheet of paper, they will perceive blue or violet (the complement of yellow) diamonds, the spaces left between the circles. This illusion of color and form is referred to as *afterimage.*

Albers explains the phenomena in this way: "One theory maintains that the nerve ends on the human retina (rods and cones) are tuned to receive any of the three primary colors (red, yellow, and blue) which constitute all colors. Staring at red will fatigue the red-sensitive parts, so that with a sudden shift to white (which again consists of red, yellow, and blue), only the mixture of yellow and blue occurs. And this is green, the complement of red."*

Explore the concepts of afterimage by collaging cut pieces of Color-Aid paper together and testing the results. Try differing patterns, color combinations, and background colors and make note of the ones that seem to be the most effective in causing afterimages to appear. We will take this notion further by applying it to three-dimensional objects as well.

Find two identical found objects and paint or gesso them white. Make a list of relating images, choose one, and develop a repetitive pattern of these images. Paint the pattern onto *one* of the found objects, using the results of your color tests as a guide. Make sure that the relationship between the object and the painted image is clear. (See *Vibration* problem.) One solution to the problem involved the use of a mannequin head painted with a pattern of illuminated light bulbs (as in having a bright idea). Another used a frisbee with repetitive silhouettes of figures flinging frisbees. A third student used a scuba-diving mask painted with fish swimming across the glass surface. In all these examples, the pattern image relates conceptually to the object on which it is painted.

Place the painted object next to the blank white-painted object. After staring intensely at the painted object, the viewer should perceive ghost images (afterimages) floating on the blank object. These silhouettes exist only in the viewer's perception; they become magical, quickly fading, elusive images that are endlessly fascinating. Use the concept of afterimage, combined with a witty object-image relationship, to make an engaging and interesting perceptual relationship between two found objects. (See *Visual Pun* problem.)

Related Artists

See artists lists for *Vibration* and *Visual Pun* problems.

*Josef Albers, *Interaction of Color* (New Haven, Conn.: Yale University Press, 1963).

VIDEO SEQUENCE

PROBLEM:

Conceptualize a short videotape through a series of sequenced still images.

So much of what is available for viewing on television is truly awful. Major networks pander to the lowest common denominator of taste, the ratings system seem to be the only logic for programming, and the visual aspects seem barely to have been explored. But if it is true that television is a vast wasteland, it is equally true that video is an incredibly fascinating medium, with almost unlimited visual possibilities. Video artists have been exploring alternative uses of this medium for years; in this problem we will use video both as a visual and conceptual source of imagery.

SCENARIO: You are at home watching TV. Nothing special is on, but you're tired and bored and it's something to do. Maybe the evening news is on, or a sit-com, or an advertisement. It doesn't matter; you're really not paying that much attention. But out of the old expected images, something unexpected starts to happen. Whatever should have come next isn't there. Instead, a fantastical image is starting to grow. A short detour takes place, an image appears that becomes visual art; an oasis of art interrupts expected network programming. The piece could be a continuation of a narrative, a metamorphosis into something else, or a sequence of totally nonobjective or abstracted images. Whatever it is, it wakes you up, grabs your interest, and makes you really pay attention to what is happening on the screen.

We want to produce a storyboard or a sequence of still images that will imply a ten- or fifteen-second spot of this nature. Your piece should begin and grow out of an image seen on commercial TV. Begin by watching a lot of television. Make sketches and notes of specific single images that would seem to have possibilities as a starting point for a takeoff piece. From that image, try various ways of making the plans for a sequence interesting in some way.

We are interested in the particular quality of video light and color. Consider what makes a video picture so distinct. Remember that you are looking at light, an electronically transmitted image. Try to imbue your stills with a sense of these patterns of light and color. Research what makes video work, how your TV set functions. Play with

the controls of the television; tamper with the vertical control, manipulate the horizontal hold. Look at things distorted in this fashion as interesting images, not just irritating distractions. Watch an old movie in a blizzard of static; make all the commercials green.

Draw the sequence out on TV storyboard sketchpads (little pads you can buy that have videoscreens printed on the sheets of paper), or lay out a sequence of basic videoscreen shapes. Try using felt-tipped markers or some other kind of transparent medium that may help your drawings look related to light. The videoscreen is the picture plane; plan the composition of each drawing according to this rounded-corner rectangle. To get accustomed to this format, try drawing the basic compositional components of a TV scene directly on the screen with felt-tips. You will have to work fast, drawing and erasing, as a typical TV shot is only a few seconds long.

Mount your sequence on a board so that it is easily followed. The piece should be visually rich and narratively complete. The sequence should look as though it is related to the light and color qualities of video as well as to the scenario stated above. This kind of thinking and planning and understanding of format can then be carried to actual video work, if the necessary equipment is available.

References

BATTCOCK, GREGORY, *New Artists Video: A Critical Anthology.* New York: E. P. Dutton & Co., Inc., 1978.

BENSINGER, CHARLES, *The Video Guide,* 2nd ed. Santa Barbara, Calif.: Video-Info Publications, 1979.

Related Artists

William Wegman
 and his dog,
 Man Ray
Dan Graham
Vito Acconci
Keith Sonnier
Nam June Paik
Joseph Beuys

Chris Burden
Peter Campus
Charlemagne Palestine
Penny Simmons
Douglas Davis
Joan Jonas
Terry Riley
Phil Makanna

See Color Plates 7 and 8.

MACHINE

From a problem by Lou Ocepek.

PROBLEM:

Do a painting of a machinelike object that is designed and assembled in two-dimensional form from existing machine parts.

Look at metallic, shiny, fabricated, tooled, objects. Think of car parts, appliances, tools. Look at toys, guns, chrome fixtures, faucets, pipes, plumbing, utensils, insides of radios and TVs, washing machines, computers, electrical equipment. Visit wrecking yards, garages, mill supply stores, railroad yards, airports. Really *look* at machine parts. Analyze their shape and surface quality and look at them from differing angles. Do many drawings of isolated images that begin to interest you.

Cut up the drawings, and start to shift them about, juxtaposing them, thinking about form relationships and possible connections. Redraw parts in combinations. Plug them together. Try to design a totally new, nonsense object from the parts. We aren't concerned if the thing works or does anything; rather, we are interested in coming up with a mechanical image that feels solid and complete as an object that is sculpturally interesting and feels as though it may perform some mysterious function.

This is essentially a rendering problem. You must paint the object so that the reflective quality or sheen of different metallic parts is totally believable. Spend some time simply sitting and *looking* at reflections. Look at the shapes and the breakdown of colors and values. Try to see the difference in visual surface quality between polished chrome and brushed aluminum.

Do not make the mistake of trying to render metallic surfaces with metallic paint. This will simply result in a flat, matte surface that has nothing to do with reflection. Instead, use a complete range of color values in gouache, tempera, or acrylic to paint reflections as form. The shape and surface contours of an object and the reflected light are inseparable; try to feel how an object's curves and angles and edges relate to and/or form reflected light shapes. A metallic object will contain an incredible amount of color as it reflects its surroundings; it is silly to assume that a chrome object can be rendered using only values of black and white. Metals such as copper and brass will provide contrast as well as demand a completely different color range than will steel or aluminum; try inventing a completely new metal.

Let the rendering of your object simply float in a void of white, black, or a value of gray. Place it within the picture plane in the most dynamic way possible; make this very strong positive shape activate the negative space. A single figure-ground relationship like this demands that your object be looked at from an interesting angle or perspective and that the object itself be well-designed to make a strong piece both visually and conceptually.

Related Artists

PAINTERS:

William Harnett	Malcom Morley
John Peto	Chuck Close
Robert Cottingham	Richard MacLean
Audrey Flack	Don Eddy
Janet Fish	Robert Bechtle
Richard Estes	James Rosenquist
Ralph Goings	

SCULPTORS:

Charles Eames.	Ernest Trova
Solar Toy	William Crutchfield
(Do Nothing	Jean Tinguley
Machine). 1957.	Dennis Oppenheim
Richard Stankiewicz	Alice Aycock
James Seawright	Eduardo Paolozzi

Petie Brown. Tempera.

Lori Decker. Tempera.

WORD-IMAGE COMBINATION

PROBLEM:

Make marks in a systemized fashion on graph paper to combine an object and the letters of its word or name into a single image.

By working on graph paper and filling in, or allotting, a single dot or mark to each square in the grid system, we can devise an image that is related visually to both computer-printed art and a pointillist painting technique. (See *Pointillist Portrait* problem.) Dots of differing colors placed in adjoining squares will result in a sparkling color that is formed by color mixture; alternating dots of red and yellow, for example, will be perceived as orange. Leaving some squares open will result in a lighter color; adding black dots will make the color darker; adding dots of complementary colors will change the intensity of the perceived color. With careful use of this method, we can set up a kind of ordered pattern of marks that will focus into a recognizable image overall.

This image will be the combination of an image and its word or name. For example, the image of a snake could be sinuously winding itself into the word *snake* in script. The word *paint* could be incorporated into a brushstroke as it is laid down on a surface with a loaded paintbrush. A line of letters spelling out *choreography* could be given human limbs and placed in various ballet positions.

Make idea sketches of many ways of combining typography with a picture. Put the image combinations into a relating situation or background. The snake image could be in a jungle, or in the sand, or on a pile of rocks. The choreography letters could be stretched out on a stage, in performance, or lined up at a practice bar. Work with felt-tipped markers and draw the images carefully in rich, solid color. Then translate the

general contours to the graph paper with pencil. Now use the felt-tips, or a painting medium, to make a system of patterned marks that combine to make the desired color and imagery.

Think carefully about the size of the squares within your grid system to the size of the picture plane. If your graph paper has $1/16"$ squares, you should work on a fairly small picture plane (around 6" by 12"). If you want to work large, consider making a grid system of $1/2"$ squares and using color coding dots with sticky backs that can be purchased at office supply stores. No matter what size you work, there will be an optimum viewing distance. Using very large dots will require getting farther away so that a nonobjective pattern of dots eventually focuses into a recognizable image. Billboards are an excellent example of this aspect of the problem. Up close, the images are a meaningless, though beautiful, pattern of halftone dots. When viewed from the highway, these huge dots focus and become a detailed photographic image.

Make the word-image combination witty and interesting within a relating background. Use rich color combinations, dynamic composition, and a system of marks, dots, or squares of color in grid system patterns to form a strong and engaging whole.

Related Artists*

Ed Ruscha	H. C. Westermann
René Magritte	Dottie Attie
Shusuku Arakawa	Alexis Smith
Bruce Nauman	Robert Indiana
William T. Wiley	Jasper Johns

See Color Plate 9.

*See also *Pointillist Portrait* problem for list of artists using pointillist techniques.

N E O N

PROBLEM:

Make a painting that explores the light quality and sculptural form of neon signs as its basis.

Neon signs are a particularly beautiful source of visual imagery. It is no wonder that a number of artists have adapted this signmaker's material as a sculptural medium. In Las Vegas, neon is carried to extravagant and baroque heights, and it seems as if even the smallest towns in America have at least one business with a neon sign. (My personal favorite is a perpetually bucking horse complete with rider on a bar front in a small Montana cowtown.) The color and light quality of neon, as well as the folk art aspects of its particularly unique linear form provide the basis for this problem.

Spend some time seeking out interesting neon signs where you live. Look at the imagery and objects and typographical elements in relation to the size and shape of the sign and the business it is advertising. Begin to consider how a particular sign could be placed compositionally as a painting within a picture plane. Make drawings or photographs of your chosen sign from differing angles and distances. Crop in and blow up just one part of the sign, or pull back and depict the sign within its environment. Make exhaustive color notes and really *look* at the specific light quality, glow, and reflections inherent in neon light.

The structure of neon signs is an integral part of their visual interest. Although we often see glowing linear shapes that seem to float, unattached, in the night sky, the bent-glass forms, fastening devices, and construction of the electrical elements are also a part of the beauty of neon signs. Think about using the underlying sign shapes and painted surfaces as a part of your

piece. Some neon signs use moving images set up in series that flicker on and off rhythmically. This changing motion and color could be implied to make your painting more dynamic.

Draw your chosen compositional solution in pencil on a sheet of illustration board. Use paint or markers to render the sign and its unique luminescent light and color quality. Choose a painting style that will communicate the aura and color of neon. Think about outside light sources or time of day. Although neon is seen best at dusk or in the dark, photorealist painter Robert Cottingham has explored neon signs and their underlying structural components as they are seen during the day, in the sunshine.

Combine the choice of a unique and interesting neon sign with strong composition and perspective, well-rendered light and color quality, and an interesting painting style or technique to make the most interesting painting possible.

References

ANSALDI, RICHARD, *Souvenirs from the Roadside West*. New York: Harmony Books, 1978.

MACK, KATHY, *American Neon*. New York: Universe Books, 1976.

Related Artists*

SCULPTORS:

Chryssa	Mario Merz
Stephen Antonakos	Dan Flavin
Bruce Nauman	Rockne Krebs
Billy Apple	Larry Bell

See Color Plate 10.

*See also *Machine* problem for list of related painters.

POINTILLIST SELF-PORTRAIT

PROBLEM:

Enlarge a Polaroid SX-70 color self-portrait onto illustration board in a pointillist painting technique using only the three primary process colors and black.

The appeal of this problem lies in the unbelievable quality of a basic color theory rule: in pigments, all colors can be made from the three primary colors of red, yellow, and blue. In this problem, all the subtleties of a color photo will be reproduced through the use of the slightly different primaries used by the printing industry.

To print a color photo on a printing press, an image is broken down photomechanically into halftone dot separations of three primaries: magenta, yellow, and cyan. The separations are then printed in transparent inks that blend together on the paper to form all the colors found in the original photo. The white of the paper and a fourth run in black, respectively, provide tints and shades of the colors.

It is possible to approximate the printing of a color photo by the use of a painting technique called pointillism. This technique involves the juxtaposition of small dots of color so that the colors blend in the viewer's eye to produce, through optical mixture, the effect of another color. Many dots of yellow and blue, for instance, would appear at a short distance as green.

Concentrating on the head and face, use a Polaroid SX-70 or any other instant color film camera, to obtain a small photographic self-portrait. Try for a well-composed image with a wide range of both warm and cool color. Superimpose a grid system drawn on acetate over the photo, and grid up to a sheet of illustration board approximately eight times larger. (A Polaroid image is 3″ by 3″; if it is blown up onto a board eight times larger, then the board must be 24″ by 24″. If the Polaroid is gridded in $\frac{1}{8}$″ squares, then it follows that the board must be gridded in 1″ squares.) Working in light pencil, translate the essential information from each square of the photograph onto the corresponding square in the grid system drawn on the board.

Using dots of the three colors, try to match the intensity and value of the colors in the photo. Use tempera, gouache, or acrylic paint mixed to match the three process colors, or purchase special felt-tipped markers that are available in these colors. To match the three process primaries, simply look in your kitchen. Almost any kind of package printed with a color photo of the contents (for example, a cereal box) will have a printer's test strip or series of dots on one of the tuck-in flaps. These dots or strips represent pure process colors.

Do a test strip to get the feel of combining these primaries to make a large variety of color. Use sparse dots for tints and dense dots for intense color, and add black dots for shades. Think carefully about the size of the dots; large dots will not allow enough detail and tiny dots become impossibly obsessive. Varying dot size and pattern will give a sense of in- and out-of-focus areas.

Using only the three primaries sets up a situation in which one is forced to form given color with limited resources. Much can be learned about the basics of color mixture, value, and intensity. Another objective, of course, is to master a pointillist painting or drawing technique to render a clear self-portrait with a shimmering, alive surface that maintains a sense of the photographic original.

Reference

LEM, DEAN PHILIP, *Graphic Master 2*. Los Angeles, Calif.: Dean Lem Associates, 1977.

Related Artists*

George Seurat	Chuck Close
Henri-Edmond Cross	Roy Lichtenstein
Paul Signac	Andy Warhol

See Color Plates 11 and 12.

*See also artists list for *Portrait* Problem.

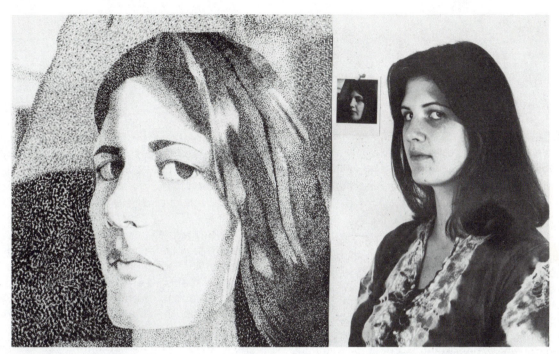

Robin Russo. Gouache.

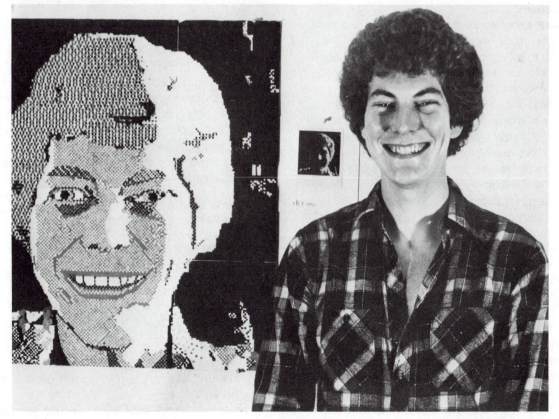

Tim Copeland. Gouache.

BAD COLOR

PROBLEM:

Deliberately use color that you hate, or that you think will not work, to make a painting that uses gameboards as a visual source.

The color quality, graphics, and overall exuberance found in the imagery of popular sources of amusement provide the basis for this problem. Games, toys, pinball machines, booths and rides on fair midways, circuses, and amusement arcades all become visual sources. The color tends to be eccentric and garish, and, oddly enough, the most bizarre color combinations seem to work in relation to the imagery found in these objects and places.

This problem will focus specifically on gameboards as the compositional, color, and image basis for a painting. Compositionally, gameboards are square, tend to have borders around a central space, and can be understood visually from all four sides. (When hung on the wall, your painting should be able to be turned all four ways.) Modern gameboards tend to be simplistic and dull; seek out old gameboards that have dense, interesting graphics and rich, complex color.

Work on illustration board cut to the size of a gameboard (approximately 13″ square) in a water-based medium such as watercolor, gouache, tempera, or acryllic. Try to plan some kind of overall theme to your gameboard's imagery and design. For example, one solution to this problem incorporated an Egyptian motif (all those terrific border patterns and hieroglyphics); another used rock 'n roll imagery (microphones, spotlights, guitars, a piano keyboard border). Use the imagery evoked by the theme to make details, borders, and complex, repetitive, patterned images.

We are also interested in depicting deep space or somehow implying two-dimensionally that objects are popping in and out of the picture plane. One beautifully rendered *trompe l'oeil* painting depicted a game actually being played, viewed from above. In addition to the board, there were cropped-in hands, markers, stray bits of popcorn, and a drink glass set on the board. Another solution implied a well of deep space, crisscrossed by steel girders and floating ball bearings.

By deliberately using bad color, the paintings done to solve this problem became incredibly beautiful. Preconceived notions of "pretty" color were shattered as the students learned to mix and juxtapose colors that they would never have dreamed of using. The students agreed in the end that the process of using color that they *thought* was bad had, in truth, resulted in some of the most exciting color they had ever seen. It showed them their misconceptions about color, gave them experience in loosening up and trying new kinds of color, and put them in touch with a more personal and intuitive color sense.

It is not our intent to make a playable game or a literal gameboard. Rather, you should explore gameboards simply as a takeoff point for conceptualizing imagery and color. Make careful use of all visual elements such as imagery, rendering, painting technique, and four-sided composition to make a well-thought-out and well-executed painting.

References

LOVE, BRIAN, *Great Board Games*. New York: Macmillan Publishing Co., Inc., 1979.

PRITCHARD, DAVID, ed., *Modern Board Games*. New York: Hippocrene Books, Inc., 1976.

Related Artists

Richard Lindner	Roger Brown
Robert Indiana	Carl Wirsum
Art Green	Jim Nutt
Deborah Remington	Gladys Nilsson
Ed Paschke	Christina Ramberg

See also Color Plates 13, 14, and 15.

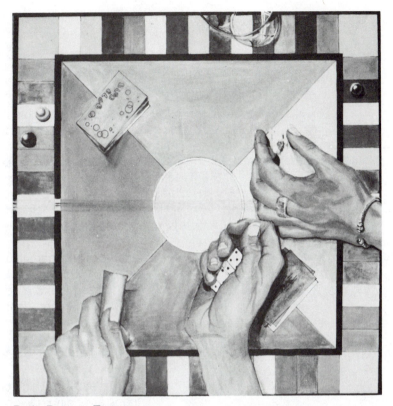

Petie Brown. Tempera.

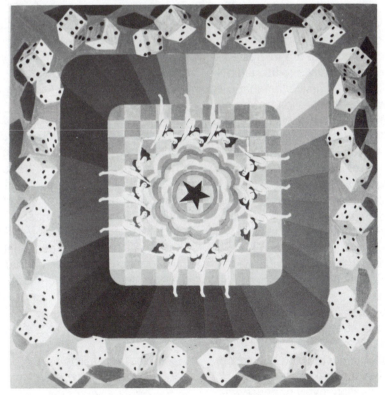

Dale Martinetti. Tempera, Color-Aid paper.

WORD LIST PAINTING

PROBLEM:

Make a painting that incorporates *all* the word images on a predetermined list as its subject matter.

In this problem, the whole class must work from the same list of words to arrive at individual paintings. One class, for example, did paintings based on these words:

a Swiss army knife
a white cowboy suit
a neon sign
a flamingo (any color but pink)
a box of crayons
a window
water
fire

Each person in your group will do a painting that somehow incorporates a decided-upon list of objects into a place or space. We are interested in a narrative solution; try to imply a relationship between objects placed within a situation that can make visual sense out of an interaction between them. The fascination of the project lies in the incredible differences in peoples' thought processes and ideas. Much can be learned from observing the way each artist uses a specific list of images; there will be wildly differing settings, implications of stories, compositional solutions, rendering styles, moods, colors, and light sources.

Begin by analyzing the words on the list. Set up relationships and connections between them. Think about all connotations and denotations of the words. Push the definitions as far as possible. (Water, for example, could be thought of as water in a glass, rain, clouds, steam, snow, rivers, and oceans.) Try to conceive of a situation that will somehow merge them together. Think about which images interest you most, which should be dominant. As artists, we can make visual sense out of absolutely any situation involving these images. Make lots of notes and sketches and con-

ceive many narrative combinations before attempting a final painting. Do not just simply render the objects floating within a blank picture plane, but try to find a witty and imaginative interaction within a setting that will make the most interesting painting possible.

Use of the words listed has resulted in vastly different paintings; for example,

A neon-outlined bar sitting in a desert landscape. A white-suited cowboy sits at the bar, setting fire to a postcard with a flamingo/jungle image on it. The postcard image is repeated, larger, behind a window set into the landscape. A glass of water, the knife, and some crayons lie on the bartop.

A train interior, in which cowboy-suited flamingos are riding. One of them is asleep; his hat, with the knife tucked into the band, is on fire. Neon signs are visible through the rain-streaked windows.

A Western town, the streets paved with giant crayons. A green flamingo drinks from the watering trough; a white-suited cowboy whittles. The buildings are burning, flames shooting out of the windows.

Work on illustration board in gouache, tempera, or acryllic. Try to work in a painting style that will be in keeping with the concept of the planned narrative situation, as well as communicate the indicated objects. Plan the color carefully, thinking about light sources to create a mood or ambiance. Color and light should be a major concern. Plan these elements with care to make a rich, strong piece that enhances the narrative interaction of the images.

Related Artists

See artists lists for *Object/Place Illustration* and *Literary Source* problems.

See Color Plates 18 and 19.

PROBLEM:

Do a painting that uses a written description of a place as source material.

Find a piece of literature that contains a written description of a place that somehow strikes a chord within you. It should not be an account of actions or characters within a story, but simply of a place, or setting. Try to use the author's words to make the place alive visually for you. We are interested not only in depicting the physical elements, but in the mood or ambiance or *feel* of the place as well. It is pointless to use a work that bores you or says nothing to you. Try to find a writer whose work excites you. Choose a passage that is rich in possibilities for visual imagery and that will stimulate your imagination.

The following description is from *In Patagonia* by Bruce Chatwin:

> Opposite, the *meseta* of Lago Buenos Aires tilted upwards to the West. Its walls rose off a jade-green river, a sheer rampart two thousand feet, layer on layer of volcanic strata, striped like a pennon of chivalry in bands of pink and green. And where the *meseta* broke off there were four mountains, four peaks piled one on the other in a straight line: a purple hump, an orange column, a cluster of pink spires, and the cone of a dead volcano, ash-grey and streaked with snow.
>
> The river ran down to a lake, Lago Ghio, with water a bright milky turquoise. The shores were blinding white and the cliffs also were white, or striped horizontally white and terracotta. Along the north shore were clear water lagoons of sapphire blue separated from the opaline water by a band of grass. Thousands of black-necked swans studded the surface of the lake. The shallows were pink with flamingos.*

This passage is about an actual place, and the author, obviously entranced by his surroundings, has imbued the description with a kind of lush appeal. Think about the nature of the passage that you choose. Chatwin's is sumptuous and rich; another may be spare and harsh. Try to make a piece that is consistent with the author's portrayal.

There are so many ways of approaching a visual description of the written word that it is difficult to know how to guide you through the problem. It could be a fairly realistic depiction or rendering of space, or it could go in a totally fantastic direction. The way the space is arranged is completely up to you; however, the best way to begin may be to sort out the basic elements of the scene. In the Chatwin writing, the basic components are a rampart, a river, four mountains, and a lake with swans and flamingos. Obviously, it is the detail in the description of these elements that makes such a difference to these features. The mountains are totally different in character and form; the color notations are spectacular and specific.

Make idea sketches that combine the basic elements and then begin to apply detail and color. Polish it in drawing form on a sheet of illustration board and begin working in a simple water-based medium such as gouache, tempera, or acryllic.

Color is as important to the piece as are the painting and rendering styles. Let the description suggest color; let the mood or feeling of the written piece suggest intensity and values of the colors. Close your eyes and try to *see* the scene. Think about light sources and how the quality and direction of light will affect the color and form of the features of the place. Early-morning sunlight, for instance, will give a different color range and light-shadow quality than will fluorescent light.

In this problem, the written word and the visual depiction should fit together, complement one another. Read between the lines; try to see what the author sees. Use the words as a source for conceptualizing a place that can become an engrossing image, a painting of immense interest and magic, that goes beyond a mere depiction of physical details.

Related Artists

Winslow Homer	Andrew Wyeth
Thomas Eakins	Edward Hopper
Albert Pinkham Ryder	David Hockney
Marsden Hartley	Neil Welliver
Charles Sheeler	Merrill Mahaffey
Grant Wood	Ed Ruscha
Georgia O'Keeffe	Robert Bechtle
Ansel Adams	Richard Estes
Richard Diebenkorn	

*Bruce Chatwin, *In Patagonia* (New York: Summit Books, 1977), pp. 82–83.

See Color Plates 16 and 17.

OBJECT/PLACE ILLUSTRATION

PROBLEM:

Do a painting that uses a randomly picked object set in a relating place or situation as its basis.

Using Richard DeMille's book *Put Your Mother on the Ceiling** as a guide, I wrote the following exercise especially for use with this problem. *It is crucial that you do not read it,* but rather find someone to read it to you as you sit with your eyes closed. Have the person read each phrase slowly and then pause; try to conceptualize the images in your mind. Later, sit back and let memorable images come back into your mind. It helps if this is done in a group; much can be learned by discussion of the imagined imagery. Particularly, take note of your viewpoint in the situations and how objects functioned in relation to their surroundings.

EXERCISE:

Think of a balloon on a string./ Make the balloon huge./ Turn it into a hot-air balloon./ Make it red./ Let it go up into the sky./ Turn the balloon green./ Turn the sky orange./ Let the balloon float out of sight./ Suck the sky down into an orange ball./ Turn the ball into a fruit, an orange./ Turn the orange blue./ Is it still an orange?/ Turn the fruit into the moon./ Let it rise into the night sky./ Make the stars large and brilliant./ Make the moon the color of flesh./ Turn it into the face of someone you know./ Let it float in the night sky./ Add a body./ Let the person stand on a star./ Put the stars on the shoes./ Look through the stars./ Make them transparent./ Do you see the toes and bare feet?/ Watch the feet walk through the stars and planets of space./ Make the stars grains of sand in space./ Make lots of grains of sand./ Make a beach./ Turn the black of space into the sky and ocean./ Turn the sky silver, the ocean golden./ Walk the feet through the sand./ Make the sand and sky and sea white./ Turn it into snow./ Walk the feet through the snow./ Walk them out into the distance of the snow./ Watch them recede./ Look at the footprints in the snow./ Turn the snowy landscape into a brick wall./ Walk the footprints up and over the wall./ Make the footprints disappear./ Cut the shape of a cow out of the brick wall./ Set the silhouette up in a green meadow./ Make the cow black and white./ Now make it yellow and turquoise./ Make it striped./ Give it a unicorn horn./ Give the cow wings./ Make the cow flap its wings and fly over the barn./ Make it land at a major airport./ Sit it down next to a Boeing 747./ Make the cow as big as the 747./ Turn the cow into a red pick-up truck./ Drive the pick-up out onto the runway./ Drive it across a map of the United States painted on the runway./ Stop in Arizona./ Put the truck on an Arizona highway./ Look at the landscape./ Drive very fast down the highway./ Drive faster./ Faster./ Look in the rear-view mirror./ See a flashing blue light./ Make the flashing light red./ Make it green./ Make it hot white./ Make it stop flashing and shine like a spotlight on a dark stage./ Make the light on the stage smaller./ Make a dot of light./ Pick the dot up./ Make your mind dark./ Put the dot right behind the bridge of your nose./ Make the dot smaller./ Make it a pinpoint in the darkness./ Make it disappear./ Make your mind dark./ Sit quietly and let memorable images come back into your mind.

Someone must prepare a batch of slips of paper containing words that name objects. Draw a slip at random. You're stuck with this image as a basis for making a painting.

Use the sensibility gained from the exercise to help you conceptualize a variety of places and situations that somehow integrate the object. Let yourself dream and muse. Let the image change size, color, texture. Think about what the object does or is used for; try negating that function. Make visual analogies or puns on other relating objects. Deliberately put yourself through a process of immersing yourself in the possibilities of this image; become obsessed by it.

Do many idea sketches from these thoughts. We are interested in a witty, clever solution to using the object as a base image. Through this process the object may become totally secondary to relating images or places. That's okay. This will be especially helpful if you particularly loathe the word you picked; let images that interest you more relate to the base image.

Some results of this process are the following:

NECKTIE: Mount Rushmore is in the background, a huge tie around the neck of one of the presidents. Patterned with tiny green Army jeeps, the necktie flows down ledges and cliffs into the foreground.

JUNGLE: There is a cropped-in view, chin to waist, of an auburn-maned girl wearing a short-sleeved shirt patterned with minute, detailed jungle scenes. A lion's tail curls mysteriously up into the picture plane.

*Richard DeMille, *Put Your Mother on the Ceiling* (New York: Penguin Books, 1967).

SKYSCRAPER: A man dashes down a city street, a skyscraper clutched under one arm, a building-shaped briefcase in the other hand.

Think carefully about color. Plan rich, dense color. Work with Color-Aid sample color sheets, trying differing combinations until the color begins to feel right with your drawn images. Think about using deliberately eccentric color; there is no reason at all that Mount Rushmore cannot be painted dull red-violet with blue-violet shadows. Paint with gouache, tempera, or acryllic on illustration board. Plan the light source, compositional elements, and viewpoint and perspective of the scene carefully. Use a painting style in keeping with the mood set up by your choice of imagery and color.

Related Artists

Donald Roller Wilson	Roger Brown
Terry Allen	Art Green
William T. Wiley	Philip Guston
H. C. Westermann	Grandma Moses
Roy De Forest	Norman Rockwell
Peter Saul	Alfred Leslie
George Tooker	René Magritte
Jim Nutt	Salvador Dali
Philip Pearlstein	Giorgio De Chirico
Tom Wesselman	Henri Rousseau

See Color Plates 20 and 21.

Mamie Lingo. Gouache. Assigned word: "Jungle"

H. Ainsley McNeely. Gouache. Assigned word: "Necktie"

ROBOTS, STARSHIPS, AND UFOs

PROBLEM:

Design and build a model of a robot, starship, or unidentified flying object; paint the surface to imply metal, lights, plastic, glass, and so on.

Make a sturdy, sculpturally sound robot, starship, or UFO by assembling found objects together and working directly with a building medium. Consider the nature of each of these objects. UFOs are mysterious and secret; their form can be anything that your imagination devises. Robots imply a combination of human and machine forms. Starships are used for transportation in outer space. Read a lot of science fiction, research reports of UFO sightings, watch old "Startrek" reruns, go to the movies, look at Buck Rogers comic strips. Develop ideas for these images, making extensive idea sketches and notes. Immerse yourself in imagining these objects; have fun and make your ideas as original and personal as possible.

Choose one of the ideas to develop through plans and drawings. Think about materials and techniques. If you are interested in a specific design idea, work reductively from a block of styrofoam or a plaster form, or additively with wood or welded parts. Found objects, however, could be assembled and the model could begin to develop from a looser working method. (See *Found Object Figure* problem.) A starship incorporating beer-can fuel tanks or a robot based on an auto headlight begins to make a visual pun on the nature of common objects.

Once the piece is assembled, spray paint or gesso it entirely white. The surface of the object can then be rendered in paint rather than depending on light to activate actual surfaces. Use acryllic or gouache to *imply* two dimensionally reflective surfaces and lights. If you have designed a bright red starship, it is not enough to simply paint your model red; you must also communicate the reflections and shadows that a red starship traveling through space would actually have. A row of white lights must be painted to look like light in plastic or glass bulbs; the glow or aura that falls on adjacent surfaces must also be rendered. Use light sources within the object as well as implying an outside light source; let these light sources be your guide for painting shadows and reflections on your model. Think about technology, either real or imagined, and use details, or graphics that will make the model believable. Paint the three-dimensional model with a rendered surface that will communicate what the model would be made of if it could become a real, workable object. (See *Machine* problem.)

Reference

MALONE, ROBERT, *The Robot Book* (A Push Pin Press Book). New York: Jove Publications, Inc., 1978.

Related Artists

See artists lists for *Machine* and *Found Object Figure* problems.

See Color Plate 22.

CAMOUFLAGE

From a problem by Sam Norgard.

PROBLEM:

Paint an actual three-dimensional object so that it is camouflaged against a background of found pattern or texture.

To camouflage means to disguise something, by painting it or screening it, so that it is lost to view against a background. It implies secrecy and hiding, concealment and deception. The military uses camouflage to keep information from the enemy. Animals are provided with natural camouflage for survival. (A good example of this is one of those photographs of apparently empty landscapes with the caption: "There is a herd of deer in this photo. How many can you spot?") Hunters of the animals wear wonderful gear in green, mottled patterns to keep from being seen by the game; it has always seemed absurd to me that they have to wear Day-Glo vests to keep from being shot themselves.

The problem is not only to camouflage the object but also to make it relate to the environment in which it is placed. Camouflage can be approached in a number of different ways:

Technical *tour de force*. The object is painted so well that the viewer has great difficulty in discerning its presence.

The ostrich theory. This is a negation of, or pun on, the theory of camouflage. The object becomes extremely interesting when painted with the background pattern, but there is no way that the object will ever disappear. The absurdity of this fact makes a witty comment on the problem.

Humerous relationship of the object to the background pattern. In the example, the Volkswagen breaking out of the picture

plane of the road map is directly related in concept to the background pattern.

There are many possible solutions to the problem. Begin by looking for some kind of pattern or background texture: fabric, wallpaper, Contac paper, wrapping paper, linoleum, Formica, and so on. For each pattern that is considered, try to think of objects that would relate to it in some way.

Once the object and the background are chosen, construct a simple shadow box or platform pedestal and line it or cover it with the background material. Think carefully about the proportion of space around the object and the compositional placement of the object within the space.

Paint the object carefully to match the texture or pattern perfectly in color and rendering. The object may have to be gessoed or spray-painted flat white before painting. While working, try to approximate the light source in which the piece will be seen so that the color will match.

Generally, try to paint the object so well, with such attention to rendering, color matching, and lighting that the viewer will have difficulty seeing the object at all. Conceptual variations can be made by thinking carefully about the object chosen, its relationship with the background, and the sculptural placement of the object within the shadow box.

Reference

BEHRENS, ROY R., *Art and Camouflage: Concealment and Deception in Nature, Art and War.* Cedar Falls, Iowa: The North American Review, University of Northern Iowa, 1981.

See Color Plates 23 and 24.

POPBOOK

From a problem by Mark Witten.

PROBLEM:

Make a popbook that illustrates one of the seven days of creation as described in the Bible.

Children's books and greeting cards often use the principles of popbooks. A popbook lies flat, like any book, but when it is opened flat paper images attached to the pages with folded strips of paper are pulled so that the images become three dimensional. In this problem, we will use two pieces of illustration board that are taped together along one edge. When the pages are opened, flat images made of paper or heavy tagboard and fastened between the two boards with folded paper will pop up into space. Pulling the two boards apart unfolds the connective strips, and it is this tension between the planes that makes a popbook work.

There are many ingenious ways of constructing popbooks that are extremely difficult to explain in words. The best way to understand these principles is to go to bookstores and libraries and look at children's books to understand their function. Take notes and manipulate the books so that you understand thoroughly how they work. Try making sample popbooks from scrap paper until you are familiar with the construction. The principles involved are easy and ingenious; in no time at all you will be designing your own methods of making folded, fastened paper into three-dimensional images.

Find a copy of the Bible and read Genesis 1, which describes the seven days of creation. Let the words bring to mind ideas and images for working on your popbook. The subject matter is certainly broad enough; the seven days of creation are an incredibly rich source of imagery and narrative elements. Approach the problem from several directions, trying to develop the most interesting solution you can from these given elements.

Choose one day, make many idea sketches and notes, and begin to design the paper forms and spatial organization of your popbook. Don't forget that you are not only working with width and height, but you also must consider that you will be layering images back into space—depth. Begin working on flat images on heavy paper in a painting or drawing medium. At the same time be planning two-dimensional images for the double backboards. Cut the images out and combine them with the necessary paper mechanical parts to make them pop up.

Craftsmanship is of utmost importance. Your popbook should be smooth and flat when closed; when it is open, the images should pop up smoothly and be sturdy and well fastened. This combination of two-dimensional and three-dimensional elements is fascinating and fun to play with. Plan the compositional organization carefully. Make it complex enough to be interesting mechanically. Use strong color and careful rendering to make the images from your chosen day clear and engaging to the viewer.

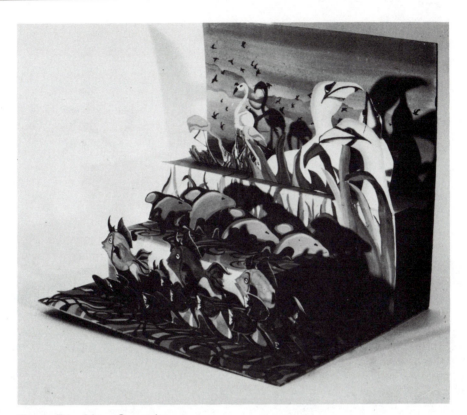

Karen Raschke. Gouache.

Karen Kelly Keltner. Mixed media.

PAPER RELIEFS

From a problem by Joan Ballou.

PROBLEM:

Make a list of one hundred sculptural materials and use it to make a paper relief sculpture.

Draw up a list of at least one hundred sculptural materials. Try to go beyond traditional materials such as metal, stone, and wood. Contemporary artists have explored many alternative materials as diverse as neon and rip-stop nylon, earth, steam, and water. Try to expand your thinking about media. Visit places you have never been: heating, plumbing, and electrical supply stores; a boatyard, a plastics factory, a construction site. Familiarize yourself with the contents of lumberyards, hardware stores, and surplus outlets. Take a walk through the woods or down the beach. Use your eyes and really *look* at materials and objects as possibilities for scuptural form.

After writing out the list, Xerox or copy the list in some way, or put the words down on paper in some kind of interesting typographical design. Use the paper or several copies of it, to build a small paper relief sculpture. A relief form is one that projects out of some kind of background, such as a wall. In bas (low) relief, a structure projects only slightly; in haut (high) relief, the forms project to a considerable depth.

Paper can be manipulated into three-dimensional form in many ways: it can be folded, bent, crushed or pulped. Paper is easily cut, torn, shredded, burned, or pierced. Paper can be piled up or layered, reassembled, or re-formed. Play with paper in many ways to evolve several forms. These could be combined together, or a single form may be strong and interesting alone. Think carefully about three-dimensional composition; the form must be interesting from many points of view. Use surface texture and the pattern created by the words to enrich and heighten the visual aspects of the basic form.

Use simple fastening devices to fasten your form together: glue, tape, staples, pins, or paper clips. Use these elements to enhance the form or become interesting surface additions. Use white paper to make the form. Manipulate lighting so that shadows and highlights make the surface and contours of the form more prominent visually when it is mounted on a wall or tabletop.

This problem combines representative symbols (words) of sculptural materials with the simplest of these materials (paper). Let these elements combine with light quality and fastening devices to make a strong relief sculpture. Let the information gained from compiling the list and making simple sculptural forms carry through to further, more complex sculptural explorations.

Related Artists

Louise Nevelson
Lee Bontecou
Dan Flavin
Donald Judd
Cynthia Carlson
Alvin Loving
Beth Ames Swartz
Linda Benglis
Michelle Stuart
Jo Zucker
John Oculick

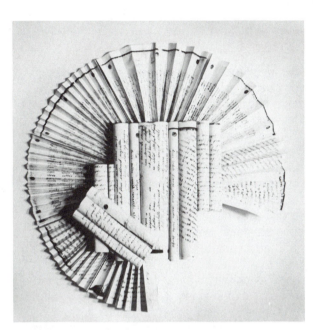

Diana Paver.

Laura Jean Needham.

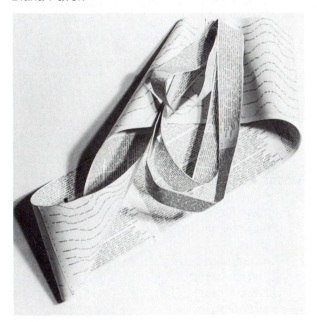

Darlene E. Chenevert.

Andre Garcia.

BAS RELIEF REPETITION

PROBLEM:

Make a bas relief sculpture from repetitive found objects.

There is something irresistably intriguing about the patterns and interrelationships made by repetitive objects. One culvert pipe lying by the side of the road is no big deal, but pile up two hundred or so and the resulting modular system and structure becomes fascinating. A line of fifty old-fashioned bathtubs in a junkyard once sent me into convulsions of laughter. A wall of piled-up chicken cages sets up a structural grid system; the chickens themselves add repetitive variations within each module.

Find or buy a large number of a single found object. You could use common objects such as hair combs, corks, sunglasses, or clothespins. Or you can seek out objects that will not be as readily recognizable, such as obscure car engine parts that have a pleasing shape but no easily named function.

We are interested in combining these repetitive objects to make a bas relief sculpture that will come off a wall surface. The objects themselves may be fastened together in some way to make a larger object that will hang on the wall. Or you may need to attach them to some kind of backboard or supporting form.

Repetitive shapes can set up a variety of rhythms, patterns, and interweavings. (See *Repetition* problem in Section I.) They can be arranged to imply motion or directional change. Many single objects can become parts of a larger modular system. They can be extremely organized or combined in a more chaotic fashion. The nature of your object may imply a particular compositional solution. One piece made of pencils was first designed as a rigid structural system until it was discovered that the pencils were made of plastic that was painted and textured to look like wood. By heating, bending, and twisting the pencils into

fanciful shapes, the artist was able to make a composition of intertwining, moving forms that made a witty visual pun on the expected nature of the found object.

Color can play a large part in this problem. Objects can be used as they are found, or they may need to be painted to heighten your visual concerns. An overall, consistent color may add harmony to disparate parts; a color system could enhance rhythm changes or implied motion. A loose painterly use of brushstrokes and color could add surface interest to a dull, uninteresting form.

Bas relief sculpture can be viewed from the front or from the sides. A straight-on view will differ from what is seen from the side; illusions or changes in form could become part of the piece as the viewer moves around it. Pay attention to all formal elements of both two- and three-dimensional design. Make the piece structurally sound and well crafted.

Reference

NELSON, GEORGE, *How to See.* Boston: Little, Brown, and Company, 1977.

Related Artists*

Alexander Calder	Cynthia Carlson
Christo. *Running Fence.* 1976.	Carl Andre
	Kenneth Snelson
Lynda Benglis	Eva Hesse
Chryssa	Donald Judd
Joseph Cornell	Dan Flavin
Nancy Graves	Sol LeWitt
Walter De Maria	Ant Farm.
Louise Nevelson	*Cadillac Ranch.*
David Smith	1974.
Ernst Trova	

*See also artists list for *Repetition* problem in Section I.

Laurie L. Bohart. P-V-C pipe joints and paint.

Christine Karas. Sunglasses.

BOAT FORM

PROBLEM:

Build a sculptural boat form from found organic, natural materials.

The Gulf Coast of Florida is Hobie Cat Country. These high-tech catamarans with their brilliantly colored sails, double pontoons, and suspended trampolines are a product of a kind of space-age design concept that stresses practicality, modern lightweight materials, and speed. In contrast, one can go a few miles inland and discover the economically sleek, simple, and classic canoe slipping quietly down a spring-fed wilderness river. Both these boats have the same purpose, which is to transport something or someone by means of water. But the nature, form, and function of the two vessels are vastly different.

Make a list of all the kinds of boats you can think of. Think about the inherent visual characteristics of each, and begin to consider each as a basis for sculptural form. This problem is not about building a scale model of a particular kind of existing boat. Rather, we are interested in exploring the visual definition of a boat form in more abstract terms through a particular sculptural medium.

Begin to collect organic found materials such as sticks and branches, roots, weeds, vines, and grasses. Regional differences in environment will be important to consider when collecting materials. Students in Florida, for example, are able to find a material such as bamboo that is not naturally available in a place like Montana. Try to use interesting materials indigenous to the area in which you live.

Begin to fashion a basic boat shape, keeping in mind the list of boats made earlier. Do not make sketches; work directly with the materials. Manipulating media in this fashion will begin to suggest construction methods and form; the nature of your material may determine the design and the shape.

Think about fastening systems and use a method that is in keeping with the concept of your piece. A form could be glued, lashed together with string or grass, fastened with hardware. Consider the nature of craftsmanship. Some boat forms may require meticulously clean craftsmanship; others may be enhanced by a rougher, more primitive approach.

The construction and type of boat form should imply a particular kind of sculptural presentation. If the form has a stable hull, it may sit upright on a tabletop or sculpture stand. Or a piece may need to have display holders or supports. One student built a dreamy linear sailboat form from pliable bent sticks bound with string that hung suspended, turning in midair.

Use careful construction and craftsmanship to make the form sturdy, paying careful attention to three-dimensional composition, form, and activation of space.

Related Artists

John Roloff	Jackie Winsor
Roy Fride	Charles Simmonds
Raphael Ferrer	Jim Surls
H. C. Westermann	William T. Wiley
Michael Singer	Eva Hesse
Deborah Butterfield	

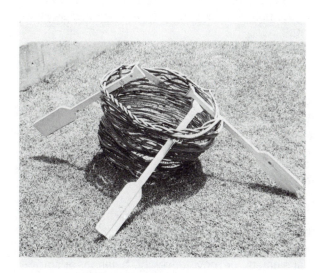

Darlene E. Chenvert. Vines, fir.

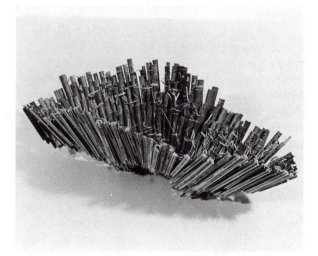

Linda Horton Dodson. Bamboo, grass.

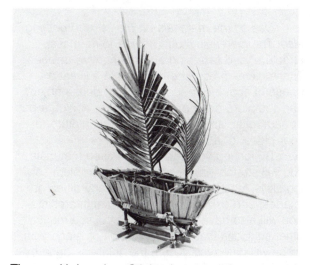

Thomas H. Lowder. Sticks, leaves, string.

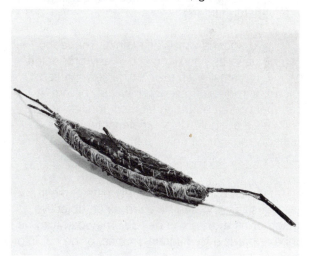

Beth Ellen Burley. Sticks, clay, string.

LIMITED MATERIALS

PROBLEM:

Make a sculptural form from a limited set of materials.

In this problem each artist within a group makes a piece using exactly the same materials. This can work in two ways. In the first, the group decides upon specific materials and then purchases a large quantity, dividing it up among the individuals. In this way, everyone works with identical media and has the same number or quantity of the decided-upon items. Fascinating variations of sculptural form are created as each individual manipulates like materials.

In the second way, a list of materials can be drawn up that designates specific materials but that also provides some leeway for each artist to make individual variations. In researching this problem, we opted for materials that could provide variable factors:

TWO SQUARE YARDS OF FABRIC: The fabric can be used as one big piece in any proportion, be cut into smaller shapes, or be sewn, rolled, folded, shredded, frayed, unraveled, or torn. It can function as a hidden element to stuff or add bulk or be a highly visible material that adds unlimited variations of color, pattern, texture, and density.

FIFTEEN SAFETY PINS: Safety pins come in varying sizes and can be used as an objective image or as a fastening device. They can also be unbent, made into different shapes, or be cut into pieces.

TWENTY FEET OF A LINEAR MATERIAL: Your sculpture can be hung, bound, or tied with rope, string, thread, or tape. Linear elements provide line quality as well as texture, color, and value. It can be a long continuous piece, cut into pieces, tied into knots, or it can be unraveled.

EIGHT BROWN PAPER BAGS: The bags are limited in color, but come in several sizes. Paper bags can contain things, be flattened out, cut up, folded, crushed, rolled, curled, shredded, textured, pulped, made into confetti, or used as stuffing.

ONE ROUND OBJECT: A round object can be a flat ring, a sphere, or a cylinder. It can be heavy or light, large or small, an objective image, a found object, or a constructed object. It can be used either as a dominant image or simply as a structural element. This object provides the opportunity to highly influence the direction or concept of your piece.

SIX ROCKS: Rocks can range from huge boulders to tiny pebbles. They can be shaped or left natural, be smooth or rough, be a purely visual element, or provide weight, balance, or stability.

Use all the materials on the list and nothing else. The materials must provide form, mass, structure, and fastening and connective devices. These elements can be installed in a great expanse of space or become a tight, dense object. The sculpture can be a freestanding object, a bas or haut relief, an installation or site sculpture, a floor piece, or a suspended piece.

By forcing yourself to use limited materials, you will stretch your mind, develop problem-solving skills, learn to conceptualize many different images, and explore your own visual interests. You will also have the opportunity to see many other solutions that you didn't think of, since your piece will differ vastly from the solutions done by other members of the group. Consider all the inherent characteristics of the materials and combine them with strong three-dimensional design to make an interesting and unique sculptural solution.

Reference

DAITZMAN, REID J., *Mental Jogging.* New York: Richard Marek Publishers, 1980.

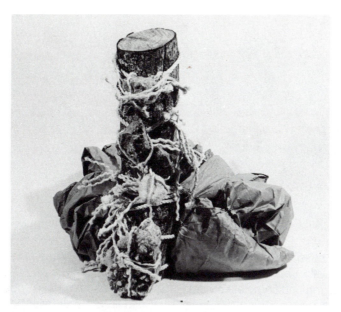

Darlene E. Chenevert.

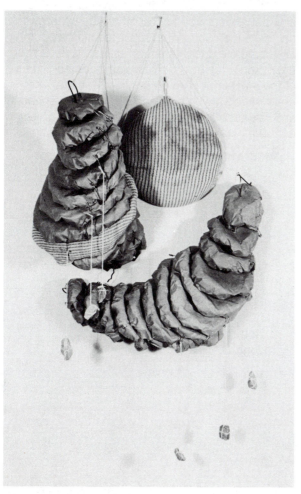

Theresa Thompson.

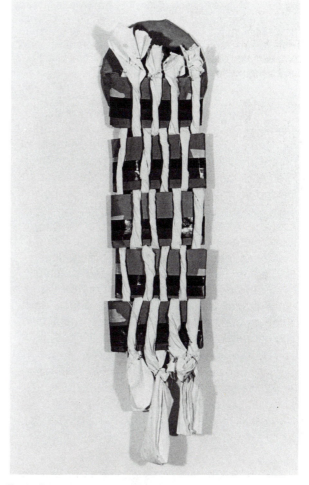

Beth Ellen Burley.

CRATE/FOUND OBJECT

From a problem by John Stewart.

PROBLEM:

Build a functional wooden crate for an object so that the two relate visually and conceptually to make a sculpturally interesting and complete object.

SCENARIO: A woman working in the shipping department of the Museum of Modern Art is getting ready to crate a retrospective exhibition of Marcel Duchamp's found objects to Los Angeles. Because she is also an artist herself, she cannot help but build crates that not only protect the work but also interact with it visually and become aesthetically interesting.

It is necessary to play both roles of this scenario. Research Duchamp, whose concept of ready-mades plays an important part in contemporary art history. Think about objects and their interest to the viewer. Choose one and call it art. Defend your choice aesthetically and conceptually, keeping in mind the second part of the scenario. Analyze the possibilities for building a relating crate. Think about echoing the shape of the object, dealing with what the object does, packaging the object sensitively and beautifully.

Consider the construction of crates. Hang out at places like airports and train depots and shipping companies and *look* at the characteristics of crates: sturdiness, unfinished wood, tight construction, economy of effort, variety of fastening systems, protective packing, stenciling of instructions. Do plans and drawings of the construction. Think, always, about the marriage between sculptural appearance and function. Build it so it will travel. Make sure that we can see the object somehow.

The crate and the object are inseparable and dependent upon each other; the synergistic nature of the relationship must result in a sculpturally complete and interesting object. (See *Synergy* problem.) The initial choice of object is one of the most important determining factors. The crate must be well built and designed to enhance and reinforce the meaning of the chosen object.

Related Artists

Marcel Duchamp
Man Ray
Alice Adams
Jackie Winsor
Alice Aycock
Jackie Ferrera
George Trackas
Ed Mayer
Robert Rauschenberg
Robert Morris
John Oculick

Liza Beth Crunk. "Escaping Saw Crate."

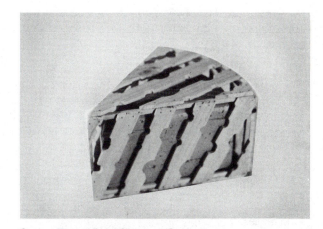

Oscar Recalde. "Cheese Crate."

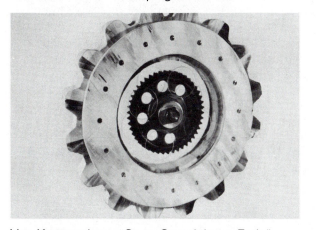

Lisa Kastrenakes. "Crate Containing a Fork."

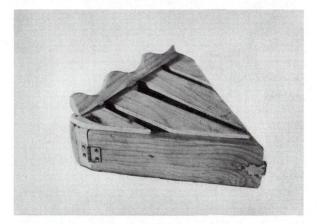

Larry Orchard. "Movable Gear Crate."

MARBLE IN MOTION

From a problem by John Stewart.

PROBLEM:

Design an object, situation, or device that will keep a marble in constant motion for exactly thirty seconds.

In this problem, you are asked to create some kind of three-dimensional situation that will keep a marble in motion and then stop it, within a given period of time. Although you may touch the marble to put it into motion, the device itself must stop the marble in exactly thirty seconds. A device of this nature is totally absurd and nonsensical, but solving a problem such as this lies at the heart of designing any functional object. Have fun with it, while designing the most elegant, effortless solution that you can.

The absurdity of this problem seemed to appeal to people when we researched it. Our time trials were attended by a wildly cheering crowd and timers with digital stopwatches. You would have thought, from the enthusiasm, that they were watching a group of superathletes rather than a tiny marble rolling through its paces.

Begin to consider what makes things move. Gravity, of course, is the most obvious. But thirty seconds is a long time, and simply dropping a marble only consumes a fraction of a second. Therefore, if your solution uses gravity, it will also have to use friction. Consider other solutions; what kind of device can push, pull, lift, or carry a marble? Think about kinds of motion: a marble can move very swiftly or at a crawl; it can spin, dance, bounce, or roll. Does the marble have to be seen, or can its motion be perceived through sound? Try to consider all the possible ways of making the marble move, no matter how fanciful or impossible, and make extensive notes and idea sketches. Choose the idea that interests you most and begin to polish it, considering materials and three-dimensional design aspects.

It is very important that you build in a variable timing factor within your device. You should be able to make adjustments in the running time when testing the device. Craftsmanship is of utmost importance; if your device is wobbly or unstable, the marble will run at differing speeds every time you test it. Keep in mind that your device must be designed to get as close as possible to thirty seconds right from the start, as it may become difficult to adjust a finished piece for more than a few seconds. One student who hadn't considered this factor built a beautiful wood structure that, when tested, only kept the marble moving for close to fifteen seconds. He kept his head, however, and installed a mousetrap at the end of the course which, when struck by the marble, catapulted it back to the beginning of the course where it ran down a second time for a total of thirty seconds exactly.

A good base concept and plans, drawings, models, test runs, elegant design, and superlative craftsmanship are all necessary in this problem. Although interesting design and perfect timing are requirements for the solutions, I appreciated the last-minute efforts of a frustrated student whose entry had fallen apart the night before the time trials. He simply put the marble in the bed of a toy pickup truck, put the truck at the top of a hill, and let it roll down and smash to smithereens at the bottom.

Be very secretive and discuss your solution only with people not involved with the problem. Guard your concept as though it is going to be patented. (Because I don't want to reveal any great solutions, I've decided against illustrating this problem.) Use your wits, imagination, and sense of humor in combination with your knowledge of three-dimensional design and materials to devise the most original and workable solution possible.

Related Artists

Rube Goldberg
Jean Tinguely

KITE FLY

PROBLEM:

Design, build, and fly an original kite.

I was driving fast along the beach highway, late for our first kite fly. I was worried; we'd had little or no wind on the days that we'd worked on the kites, and the wind tunnels we'd created with big fans to test the models just didn't seem to do the trick. I wasn't sure how our designs would function when we went to the beach to fly the kites in the strong wind off the Gulf of Mexico. But suddenly, as I rounded a corner, there they were—thirty or so kites already flying strongly above the island. I couldn't believe it—they flew!—and the kites we'd worked so hard on were finally activated and flying high in the clear blue sky.

Kites are beautifully sleek, seductive forms. They are hard to resist, these magical flying objects. Designing and building a kite results in a solid sense of accomplishment; flying it gives a feeling of power and control. At the same time, kites seem to provoke a kind of wistfulness, as they are the closest thing to *real* flying most of us will ever experience.

It is essential that you get a good kite book and learn the principles of aerodynamics that make kites fly. I have listed several, but I highly recommend David Pelham's *The Penguin Book of Kites,* as it is complete and affordable. It is also essential that you choose a time of year when the wind is blowing fairly steadily; all the principles in the world won't replace practical experience in flying kites.

Study all the designs diagrammed in your reference book and try to understand how the structure of each makes it able to be flown. Read about the history of kites; they aren't just for kids anymore. Huge structures have been able to lift the weight of a person; kites were the precursors of airplanes and hang gliders. A kite measuring 36′ by 48′ took fifty or more people to fly it. Kites have been used for centuries in Japan as a major sport. The military has experimented with kites for years.

Begin with an existing design, or design your own kite completely from scatch. If you decide to start with someone else's design, such as a Delta, Sled, or Parafoil kite, try to make aesthetic decisions concerning materials, size, color, or decorative elements to make it more personal. Some of the solutions at our kite fly were original designs. A huge hammerhead shark kite floated languidly over the Gulf, making a witty comment on the site. One of the most beautiful designs was in the shape of an arrow, impeccably crafted of beveled and patterned pieces of balsa wood. Covered with clear vinyl and sporting a long videotape tassel tail, it pointed straight up to the sky and climbed and climbed.

Consider all available materials used in kite building. Structures are often built of split bamboo, plastic, or wood and are covered with lightweight materials such as paper, sheet plastic, ripstop nylon, or silk. The choice of materials depends a lot on the design and size of the kite. One enormous sled kite flew so strongly that it immediately broke its bamboo supports. It was finally flown with large aluminum support rods, with three people clinging onto the line for dear life. Your book will outline design and construction methods.

Make a kite as an excuse for an event and a good time as well as to study three-dimensional form as it relates to aerodynamic design. We are interested in making the best looking kite possible, but it must fly. Kites are sculpturally beautiful objects on the ground, or even in a gallery, but there is nothing to compare with actually controlling its flight and seeing it activated in the sky. Make sure that your kite will fly by combining careful planning and testing with a solid, well-thought-out design.

References

DOLAN, EDWARD F., JR., *Go Fly a Kite: The Complete Guide to Making and Flying Kites.* New York: Cornerstone, Division of Simon & Schuster, Inc., 1979.

LLOYD, AMBROSE, *Kites: How to Fly Them, How to Build Them.* New York: Holt, Rinehart and Winston, Inc., 1976.

PELHAM, DAVID, *The Penguin Book of Kites.* New York: Penguin Books, 1976.

YOLEN, WILL, *The Complete Book of Kites and Kite-Flying.* New York: Simon & Schuster, Inc., 1976.

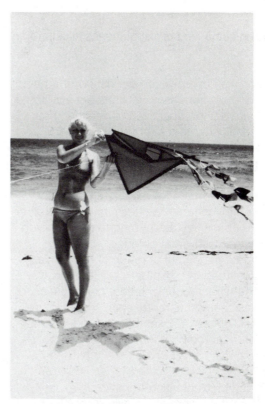

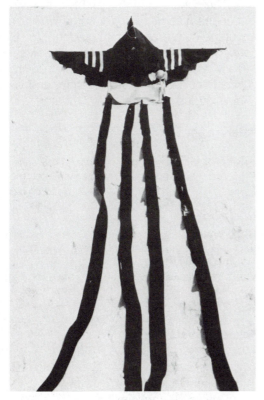

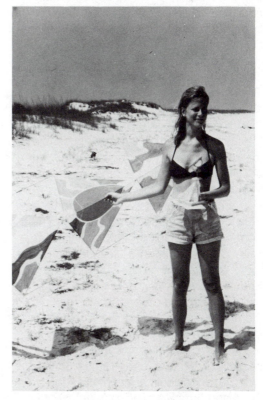

AMAZING FACT

PROBLEM:

Using some kind of visual means, illustrate an amazing fact.

Often we cannot grasp the nature of a particular piece of information until it is put into some kind of everyday perspective that relates to our own personal experience, or until it somehow is made visual. For instance, it was impossible for me to grasp the vastness of the distance from the earth to the moon until someone explained to me how long it would take to walk there under my own power. My inherent laziness makes a stroll of this nature absolutely astounding to me, bringing home this fact with great potency.

Any fact that is out of reach of our senses can be illustrated in a number of different ways: activity and ritual, documentation, performance, two-dimensional visual representation, sculptural object, installation, or assemblage. Students have illustrated an incredibly wide variety of facts in many ways:

> Ainsley McNeely tried to make us experience the length of the Nile River by drawing, on a 1 inch = 1 mile scale, a blue chalk line in and around a four-story building, and having us follow the line from the source to the sea.
>
> Jody Johnson researched the statistics on the life-style of the "average" American. Calling herself Jane Doe, she literally lived according to these figures (including the food she ate, the size of her home, and the number of persons in her household) for an entire week. She documented this activity with facts and photos, presented in a dossierlike folder.
>
> Lee Slocum relived an ancestor's circumnavigation of the globe by sea by swimming corresponding laps in a swimming pool.
>
> Tammy Cornwall set up a clean and ordered room and happily fed us chocolate bars. She then brought out a jar containing a white mouse and proceeded to read us the statistics concerning the levels of rodent fragments that the federal government allows as being acceptable in the processing of food in the United States.
>
> Tanya Starzinger built a mechanism that rotated and struck a bell every eighty-one

seconds, illustrating the number of questions that a four-year-old child asks on an average day. It was an unbelievably irritating object.

> Nancy Polito made thirty fluttering cloth forms that hung on a line outdoors illustrating the number of California condors in existence in North America at the present time, making a sad and poignant comment on ecological concerns.

These students explored something that was personally intriguing to them; with strong visual presentations, they also involved their viewers' interest and emotion.

Begin by finding a fact that is important to you in some way. It could be funny, irritate you, make you angry, or simply knock your socks off in amazement. List all the ways in which the information could be illustrated. Make the illustration consistent with the inherent characteristics of the fact. (It would be impossible, for instance, to do something comical using the statistics on the number of people killed in the Vietnam war.) Try to think of a visual representation that will be in keeping with the nature of the fact and aim for an appropriate and meaningful viewer response.

The concerns of this problem are twofold: first, to learn something about the world and about the nature of art, and, second, to illustrate a concept that interests you. Make the illustration as visually powerful as possible, remembering the elements of design, craftsmanship, and visual organization, as well as of good theater.

References

DOLMATCH, THEODORE B., ED., *Information Please Almanac*. New York: Simon & Schuster, Inc., 1981.

MCWHIRTER, NORRIS, *1979 Guinness Book of World Records*. New York: Sterling Publishing Co., Inc., 1979.

SOBOL, DONALD J., *Encyclopedia Brown's Record Book of Weird and Wonderful Facts*. New York: Delacorte Press, 1979.

WALLECHINSKY, DAVID, IRVING WALLACE, AND AMY WALLACE, *The Book of Lists*. New York: William Morrow & Co., Inc., 1977.

Related Artists

Chris Burden
Walter De Maria
Dennis Oppenheim

Pablo Picasso. *Guernica.* 1937.

David Marc Fried. "My fact represents the atrocities of war by illustrating the largest number of fatalities in one siege (the most people killed in the shortest amount of time).

From August 30, 1941 until January 27, 1944, the German army pursued an 880-day siege of Leningrad, U.S.S.R., which ended in the deaths of approximately 1,400,000 defenders and citizens. I will represent this fact by recreating the battle on a common electronic entertainment device, known as 'Galaxian.' This machine has 46 'aliens' aligned in constantly moving rows that send out flying 'aliens' at random intervals. The player (or soldier) attempts to out-maneuver and shoot the 'aliens' down with the press of a button (trigger).

I figured that in Leningrad 15,909.1 were dead per day, 662.9 per hour, 11.1 per minute. This means one person was killed every 5.4 seconds. But rather than recreating these ratios, I simply tried to kill as many 'aliens' as possible in the shortest amount of time. The purpose is to show that if a modern-day, high-technology siege was ever put forth, death would most likely come as fast as a button could be pushed.

Although 'Galaxian' is a game designed specifically for entertainment, I couldn't help getting emotionally and physically involved in this illustration. The randomness and ferocity with which the 'aliens' attacked was almost *more* than a simple threat to my computerized existence. I definitely felt as though I was constantly on the defensive, struggling (killing others for my own well-being) to survive.

Playing 'Galaxian' thus represented the theory that one person, given the technology, could kill an 'alien' every 1.3 seconds (57,926,080 persons in 880 days). The figure from the record-holding siege in Leningrad, as mentioned before, was one person killed every 5.4 seconds." (McWhirter, Norris and Ross, *Guiness Book of World Records,* New York: Bantam Books, 1973, p. 359.)

F E T I S H

From problems by Sam Norgard and John Stewart.

PROBLEM:

Make a personal, sculptural fetish object that is in keeping with your life-style in relation to the culture in which we live.

Fetishes are objects that are regarded as having spiritual, religious, or supernatural power. Found most often in primitive cultures, individuals regard these objects with fear, awe, and respect. They become a kind of charm or amulet or talisman that is worn, carried, or kept to influence one's life course or destiny, to bring good fortune, and to avert evil. Fetishes are regarded as the dwelling places of spirits.

Often these objects are very small and personal, although sometimes they may be enormous and oriented toward a whole group of people. We are concerned here with small, individual fetishes. These are sometimes carvings of wood or stone or small assemblages, bundles, packages, or pouches that are worn on the body about neck or waist or are quite portable. Fetishes are made from natural materials such as shells, fossils, bones, feathers, stones, dried animals and insects, teeth, nail parings, seeds, dried flowers and plants, leather or animal hides, and weavings. Bird and animal forms are often very important and symbolic. These fetishes reflect the readily available materials within the culture, as well as the life-style and concerns of the individuals.

Obviously, most of us do not live in the wilderness and provide our own food and have the same kind of spiritual connection with nature that primitive cultures have. Our life-styles reflect, perhaps unfortunately, an obsession with man-made objects and a removal from nature. However, within our society, we still have spiritual needs and beliefs that move in many disparate directions. Use this aspect of fetishes to make an individual, powerful object that somehow relates to your needs, concerns, dreams, aspirations, and fears from materials and images indicative of and available in our society. Use the notion of a fetish as an object of magic and strength but make the visual aspects indicative of our culture rather than trying to plug into the values of a life-style that are not, in reality, ours. One of the nicest solutions to this problem involved a tiny glass vial of mercury and tight bindings of fine copper wire.

Research fetishes and the cultures that use them. Look for analogies within our own culture. Look at the visual and sculptural characteristics of fetishes so that you understand their beauty as art objects as well as the reasons for their being regarded as powerful images. Perhaps play off on the traditional forms and imagery of primitive fetishes, and combine these notions with the contemporary issues and images of your life. Make a fetish that has meaning and power as an object to you personally, considering at the same time how it could become sculpturally and visually interesting to others as well.

References

Research fetish objects, as well as weapons and ceremonial objects, used by Indian tribes of North and South America and cultures in Africa and Australia.

Related Artists

Raphael Ferrer	James Surls
Christo	Italo Scanga
Ree Morton	Alan Shields
Jackie Winsor	Michael Singer
Nancy Graves	Eva Hesse
Deborah Butterfield	

VISUAL PUN

PROBLEM:

Make a sculptural object that illustrates the principle of visual puns.

Our purpose in this problem is to blend and/or combine two images visually or structurally to arrive at a third image indicative of a visual pun. *Webster's* defines a pun as "the humorous use of a word in such a way as to suggest different meanings or applications or of words having the same or nearly the same sound but different meanings." The easiest way in which to begin may be to work with words that name objects that can be redefined *visually* in differing ways. There are many ways to work with this concept; here are just a few:

1. Using words that name objects but could be thought of deliberately in a completely different way:

house slippers, snake boots, boat shoes: These words describe shoes worn in a specific place and name their function. However, they could be depicted visually as a pair of slippers that *look* like houses, a pair of boots that are combined with the physical form of a snake, or a pair of shoes that take on the visual or structural aspects of boats.
firearm: It is easy to make structural analogies between the shape of a gun and the shape of a hand when the forefinger is pointing straight out. Aspects of both could be blended together. The wrist could be a gun handle, an arm could become a rifle stock.
palm tree: Perhaps a tree form with little hands hanging like fruit?

2. Words that have two meanings could bring to mind two visual definitions that could then be combined:

bridge: A connective structure combined with a visual symbol of the card game bridge.
cat: A big yellow earthmover having feline characteristics.

3. Objects whose purpose or function becomes negated by alterations in physical appearance:

flip-flops: These sandals are supposed to be easygoing and lightweight. Their function could be negated by giving them four-inch, brick-walled soles.

4. Bringing images together that relate a statement or point of view about something:

oil companies/big bucks: An oil derrick covered completely with paper money.

What could you do with *flea market, barnstorm, walleye, footlights, hogwash?* Pretty corny, huh? But you know what they say—the best puns are those that elicit the loudest groans.

This problem should be fun, the solution extremely witty visually. Work through drawings first. Try to blend the form and structure of two objects to make a well-designed, sculpturally sleek object that makes visual sense. As artists, we can manipulate form in any way that we please and render combinations of objects that are impossible realistically. Begin thinking about how best to construct the object: what medium would be best suited to your idea? You could start with a found object and somehow manipulate the form or surface, or you may need to work from your drawings and completely build the combination object using something like clay, plaster, styrofoam, or papier-mâché.

Think carefully about illustrative style and sculptural form as well as surface, details, and color to arrive at a clever and complete piece that slyly communicates the visual pun intended.

Related Artists

René Magritte	David Gilhouley
Marcel Duchamp	Ken Price
Meret Oppenheim	M. C. Escher
Man Ray	Red Grooms
Claes Oldenburg	John Oculick
Fumio Yoshimura	Roger Brown
Richard Shaw	Art Green
Marilyn Levine	Trevor Winkfield
John Pfahl	Ronald Davis
Robert Arneson	

L U R E S

PROBLEM:

Make a sculptural object that uses fishing lures as a conceptual and visual source image.

Almost everywhere you travel you'll find people who are crazy about fishing. And every fishing nut has a favorite kind of bait or fly or lure. Fishing lures are incredibly beautiful objects. They flash, spin, wiggle, have gorgeous colors and glitering surfaces and textures and enticing forms. They also have terrific names like Snagless Sally, Devil's Horse, Shyster, Weed Wing, Jerk Jigger, Rippler, and Black Fury, to name just a few.

A lure attracts, deceives, decoys, entices. Your lure could work on the principles that actual lures use, but it could become exaggerated and embellished. The design of an actual lure depends on what kind of fish is to be caught and where. Some fish are attracted by color, others by motion. Lures with moving parts make certain kinds of sound when moved through the water. These notions could be taken further and much less literally. Your lure could be made even larger and more lurid. The kind of fish you are after could suggest ideas. What kind of lure would a hammerhead shark go for? One that is studded with nails and tacks?

Spend some time fishing or talking with people who fish and listening to their stories and theories or visit tackle shops. Research different kinds of fish, their physiological aspects, their environment, what they like to eat. Perhaps begin to ascribe human characteristics to them. What about a fish that is lured by greed or sexual drive? Look at fishing tackle in general in a sculptural rather than functional way. Make sketches of lures; take notes on fishing information.

Begin to devise your own lure. We are not particularly interested in making a lure that works, but rather in making a fantastical object that implies the notion of lures. There is, however, no reason why you couldn't make a lure that you could fish with that is also sculpturally very beautiful. Think about exaggerating size, color, form, surface, texture. Consider embellishment and decoration. A form could become distorted or abstracted. Make an outrageously flamboyant lure or one that is sleekly seductive. Name your lure; let the words enhance the visual aspects. Be silly, have fun, and combine a variety of materials and objects together into a sculpturally sound, interesting art object.

Richard L. Hilburn. Cork float, hook, feathers, pipe cleaners.

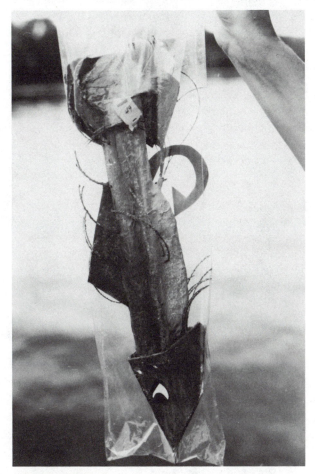

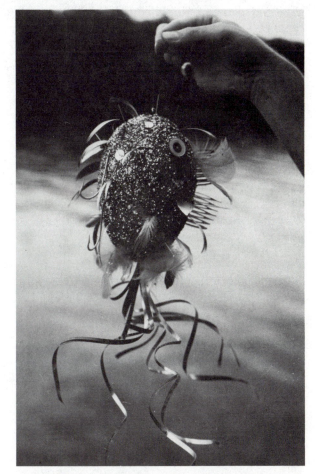

Tim Copeland. Paper mache, paint. Lee B. Slocum. Styrofoam, feathers, glitter.

TROPHIES

PROBLEM:

Use the idea of a trophy as a basis for constructing a freestanding sculptural object.

I love to go into restaurants and bars that sponsor bowling or softball teams just so I can look at their trophies. They are displayed so proudly, inscribed with the players' names and the dates of crucial sporting events. These awards and memorials are formal and nostalgic and evoke a very real sense of history and narrative. They are also a wonderful source of tacky, symbolic imagery and stiff, convoluted sculptural form. In this problem, we will explore all aspects of trophies as a basis for making a sculptural object.

Begin by looking at school trophy cases or visiting a trophy shop or looking at trophy cataloges. Note what makes them what they are; trophies seem to follow a standard, accepted format. A trophy is almost always symmetrical, with complicated, piled-up forms teetering on a base. Pedestals, cylinders, rectangular solids, and fluted columns alternately stack up higher and higher. This structure is topped with a sculpted figure or a symbolic object. Trophies are usually made of metal and wood, and there is almost always an engraved plaque attached at the base. A lot of symbolic victory images are used such as loving cups, crowns, classic winged-victory figures, and ivy wreaths. Curiously, wing forms or birds with wings outspread are often incorporated. Decorative elements such as patterned panels, coats of arms, and fleurs-de-lis are often seen, as well as the 1950s *moderne* kidney forms and daringly asymmetrical angular shapes.

In attempting to design the most formal, conservative, solemn memorials possible, trophy manufacturers sometimes come up with unintentionally absurd images. These are three of my favorites, seen in a local trophy shop:

The figure of a beauty queen that flourishes a wand with a star on the end, supported by a straining, massed assemblage of fig-

ures that resemble the Muses dressed in togas.

An enormous bowling pin that dwarfs little figures of bowlers all set to fling bowling balls off in all directions.

A desk-set award that combines a trophy, lamp, pen set, cigarette lighter, and calendar all into one piece.

In addition to athletic figures or symbols of sports like race cars and hockey pucks, one can purchase trophies with such diverse sculpted symbols as a milkcan, a state trooper firing a pistol, a military tank, a school bus, an angel fish (an angel fish?), a cactus, a bingo card, and a peanut, to name just a few. Contemplate the narrative possibilities implied by these images; they bring to mind absurd contests and hilarious situations.

Use all the characteristics of trophies, both visual and conceptual, to make a sculptural object. Make it a spoof or takeoff on the idea of trophies; use the solemn and sober memorial concept as well as the structural form and symbols. Manipulate all visual elements such as style, form, surface, color, and conceptual basis to make a witty and complete sculptural statement.

References

DORFLES, GILLO, *Kitsch: The World of Bad Taste*. New York: Bell Publishing Company, 1969.

STERN, JANE, AND MICHAEL STERN, *Amazing America*. New York: Random House, Inc., 1977.

Related Artists

Red Grooms. *Ruckus Manhattan: The Statue of Liberty*. 1975
Jasper Johns
Claes Oldenburg
Saul Steinberg
George Green
Robert Wade
Robert Rauschenberg
H. C. Westermann

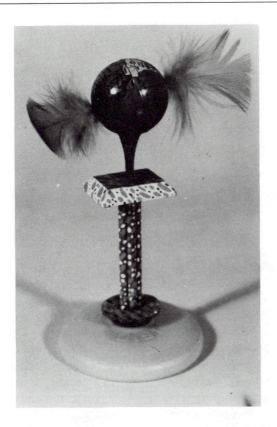

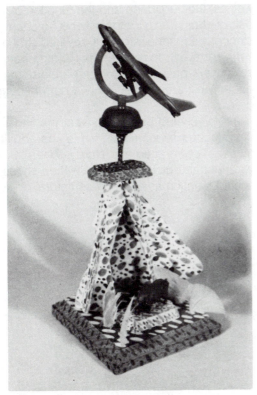

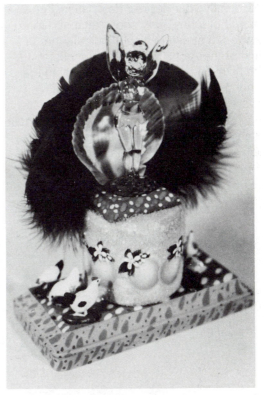

Trophies made by the author for presentation at the First Annual Kite Fly. See p. 92.

S H O E S

From a problem by Roger Shimomura.

PROBLEM:

Make a pair of shoes relate visually to a specific place or journey.

Your shoes were made for walking. Think about traveling and journeys and activities appropriate to specific destinations. Make a pair of shoes that indicate visual aspects of a place or that relate to activities that go on in a place; the appearance of the finished shoes will help the viewer to identify your desired destination. For example, a pair of funny, furry shoes attached to a sledlike wooden structure would indicate the North Pole or the Arctic. Or a pair of shoes attached to flotation devices were obviously made for walking on water. Another pair, for outer space, were blue velvet fantasy shoes with stars and suspended, jiggling moons and planets, and feathery comet trails swooping off the heels.

Look for shoes at secondhand stores or on sale or in your closet. Think about using this found pair of shoes as the basis for the problem; the appearance of the shoes may suggest a des-tination or activity. Think about fantasy trips, white-line fever, exciting places to explore. Shoes become a logical vehicle for putting across visual aspects of a place, dealing with activity within the place, or as a kind of survival kit containing images and objects enabling you to travel there.

Begin by making lists of places and sketches of images that relate to places. Choosing one idea, begin thinking about sculptural and two-dimensional media in relation to the shoes. Work with a variety of mixed-media or found objects added to the shoes to put across a sense of the place. Think about decorative elements as well as structural form and the function of your pair of shoes. A pair of sturdy hiking shoes, for instance, was made into bark-covered "trailblazers." At every step, levers protruding from the soles were pushed up, making a blade of sharp edges whiz around and mow a path through the grass.

You should be able to wear the shoes, so the attached structural elements and additions must be well crafted and sturdy. When taken off your feet and displayed, the finished shoes should function as a strong sculptural object as well.

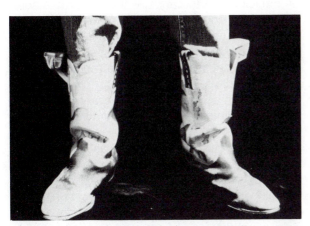

Meg Monahan. "Road Boots with Rear-View Mirrors."

Neal R. Zimmerman. Shoes, mixed media. "*The Titanic* Shoes."

Rick Lurding. Fur, wood, leather. "Polar Sled Shoes."

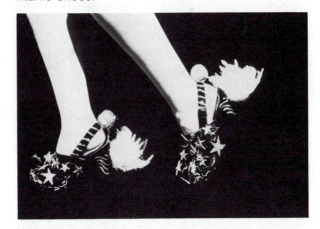

Kathy Anne Smoot. Shoes, mixed media. "Outer Space Shoes."

BIOGRAPHICAL RELIC

From a problem by Mark Witten.

PROBLEM:

Make a sculptural object or assemblage that brings to mind a specific well-known person.

The biographical details of the lives of famous people are the conceptual basis of this problem. By researching these details, we can develop certain symbolic objects that are representative of a person's profession, accomplishments, life events, personal characteristics and appearance, and quotations. Places in which the person spent time, related people, and historical events could also be used. Through the skillful combining of objects sculpturally that epitomize a particular personality, we hope to evoke the essence of that person. We are interested in making a kind of biographical souvenir of someone's life that also becomes an intriguing art object.

Begin by making lists of well-known people. Choose one or two who particularly interest you or who bring to mind many images to work with. Begin to think sculpturally by seeking a major image that will personify the chosen person and that could serve as a central form or base for the piece to be built upon. For instance, one student, using the life of Cleopatra, based her piece on a pyramid structure. Another used an easel form as the foundation for a piece on Norman Rockwell.

Think about how other symbols or forms could be combined with the basic structural object. Choose the images carefully so that they are visually harmonious and serve as straightforward, clear clues to the identity of the person being represented. Rockwell's work, for instance, is "as American as baseball, hot dogs, and apple pie." So the second major image in the Rockwell piece became a fluffy pie in a metal pie pan, attached to the easel where a painting would sit. It was painted with flag stripes, apples, baseball players, and the cover of the *Saturday Evening Post*.

The problem may be solved best by combining two or three images synergistically so that they become more interesting together than they do apart. (See *Synergy* problem.) This kind of clever melding of objects becomes sculpturally

interesting as well. The Rockwell piece combined flag, apple pie, and easel into one solid object. The pyramid image had a sinuous snake wound around the supports; the snake had a crown and long black hair with bangs, which became a combination of Cleopatra's physical appearance and the cause of her death. A piece on John F. Kennedy combined two circular forms, a target and the presidential seal, which made a pointed statement about his assassination.

You can construct the necessary symbolic objects, use found objects, or use a combination of both. Think carefully about making the assemblage as compositionally and spatially strong as possible. Pay attention to structure and craftsmanship. Color will be extremely important symbolically as well as visually. The object should make clear who the person is by a careful and intelligent combination of selected elements; it also should be a sculpturally complete visual statement.

Related Artists

Judy Chicago. *The Dinner Party.* 1973–1979.
H. C. Westermann. *Memorial to the Idea of Man If He Was an Idea.* 1958.
Cesar. *Portrait of Patrick Waldberg.* 1961.
Robert Rauschenberg. *Erased DeKooning Drawing.* 1953.
Arman. *Chopin's Waterloo.* 1962.
Edward Kienholz. *John Doe.* 1959.
Richard Hunt. *Icarus.* 1956.
Joseph Cornell. *Medici Slot Machine,* 1960, and *Homage to the Romantic Ballet,* 1942.
Marisol. *John Wayne.* 1963.
Robert Arneson. *Mr. Unnatural.* 1978.
Angelo Avelli. *Plato.* 1965.
Jean Arp. *Some Shadows: Portrait of Tristan Tsara.* 1916.
Red Grooms. *Gertrude.* 1975.
John Buck. *Aloha.*
Chris Unterseher. *The Great Jerry Byrd (steel guitar) with Patsy Cline, Hawkshaw Hawkins (piano) and the Jordanaires.* 1977.

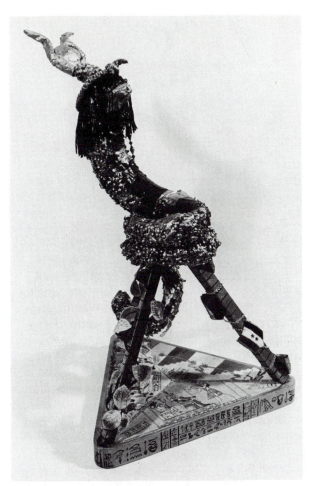

Sherolyn Sisco. Wood, paint, paper mache, found objects. "Cleopatra."

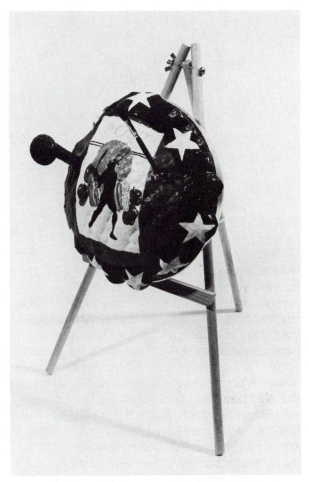

David Philip Swartz. Wood, spray foam, paint, found objects. "Norman Rockwell."

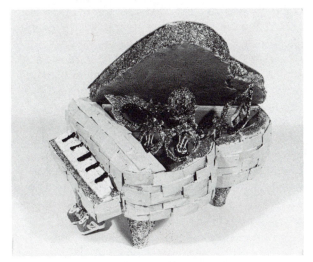

Celia L. Higbe. Styrofoam, wood, paint, glitter. "Elton John."

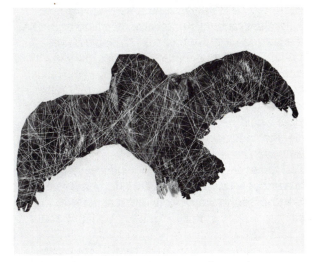

Laura Jean Needham. Paper mache, paint, string. "Edgar Allan Poe."

SURVIVAL KIT

PROBLEM:

Use the concept of a survival kit as a basis for making a sculpturally interesting art object.

A survival kit is usually thought of as a compact, portable object that contains items that will hopefully allow a human being to stay alive in a harsh or inhospitable environment. A typical survival kit would probably include medical supplies, shelter, food, and water. These items would vary depending on the place where it is to be used; a person traveling through the Sahara Desert would have completely different needs than would someone in the Andes. Making a survival kit for a specific place is only one way, however, of solving this problem. Making a kit for a fantasy or fictional place, or for a place we do not know much about such as the planets in outer space, would make a less literal basis for this problem.

Survival also can involve the mind and spirit. Begin to consider what makes people's lives meaningful and how these nonphysical aspects of survival could be incorporated into a kit. A musician, for example, would require a totally different set of survival objects than would an athlete. A poet would need different objects than would a person seeking the perfect tan. Consider hobbies, activities, professions, and passions as a conceptual base for the problem. Consider how these ideas apply to you personally and perhaps make a kit geared to your own individual needs.

A kit could be geared to a specific situation, such as going home to visit your family, or recuperating from a love affair, or being attacked in a dark alley. It could be a kit that combats fears and phobias. A kit could explore certain personalities or characters. One very elegant black-and-red solution to this problem was a vampire kit, complete with extra fangs and an emergency supply of blood.

Visually, the notion of a kit will be our base. It has connotations of portability, neatness, organization, and compactness. Your kit, no matter what the conceptual basis, must be constructed within something like a carrying case or backpack or an object that can fasten to your body. Consider all the ways of packing, or organizing, the interior space. It should, within a highly organized composition, make good use of practical yet interesting sculptural space. Use found objects or fabricate images yourself. Consider the shape and form of the container, the elements inside, graphics or instructions, and a strong use of color.

Use the notion of a survival kit to make a sculpturally intriguing object that clearly communicates a particular kind of survival purpose. Remember that we are not interested in making a practical, usable kit that doesn't go beyond the idea of a Johnson & Johnson first-aid box. Rather, we simply want to use the visual organization, sculptural space, and concept implied in a survival kit as a basis for developing an interesting art object.

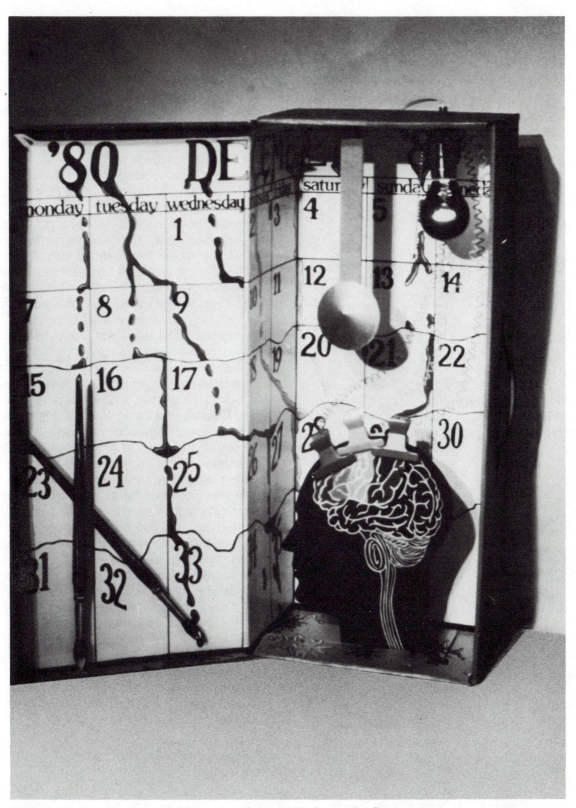

Andi Abernathy. Locker, mixed media. "Survival Kit for an Art Student."

PORTABLE LANDSCAPE

PROBLEM:

Make a sculptural landscape that is fitted inside a portable carrying case.

This problem was conceived in an airport. I was waiting for my fourth flight of the day, feeling exhausted, sick of Muzak, tired of noise and plastic seats and sealed, controlled environments. I felt tight and breathless and was longing for the sight of something that was not man-made or efficient. I began looking at the briefcases used by business executives and the compact cases carried by flight attendants. And I began to wish that I had a case of my own, one with a secret. Instead of papers or toiletries, it would contain a place, a landscape inside. Then I could simply open it up and lose myself in contemplation of nature and open space, imagining fresh air and the sounds of water or birds—pure escapism.

Begin this problem by thinking about places. Let your imagination drift; fantasize about the mountains, a prairie, the ocean. Consider the sky, horizon line, and earth relationship. Think about where you like to be and what kinds of places interest you most. Conceptualize an escape place for situations of stress or unhappiness. The place could be well known and beloved or a complete fantasy. From these thoughts begin to make idea sketches and notes.

This problem also involves the notion of compactness and portability. We are working in an extremely confined sculptural space, with very definite, tight boundaries. Begin looking for an appropriate container, such as a suitcase, attaché case, tackle box, or lunch box or construct a carrying case of your own design. Consider the proportions and size of the case relative to your concept of landscape and choose one that feels good to you in relation to that idea. The outside should be anonymous, giving no clues as to the magical space contained inside.

Once a case of some sort is found, begin planning your chosen landscape within that specific space. Consider the proportions and dimensions of the box when fitting the landscape elements inside. The lid of the case must be integrated to work with the bottom half. For instance, a shallow lid could sit upright at a 90-degree angle to the bottom. It would be logical to use a two-dimensional image in the top combined visually with three-dimensional images in the base. Deep landscape space can be indicated with a painting or a photograph; the bottom half could then function as actual three-dimensional foreground space. Or a case could open out flat to form a horizontal landscape; the three-dimensional elements could be planned to fit together when the case is closed.

Work with both two- and three-dimensional media. For instance, contours of the landscape could be built up with papier-maché or shaped styrofoam; the surface could then be painted or textured in some way. Construct certain elements yourself or combine them with found images and objects. Try to activate this confined space with intelligent composition. The notion of fitting something so vast and limitless into such a confined space is totally perverse; you will have to crop in on a chunk of landscape and fit it into the box in the most dynamic way possible.

These elements could be rendered realistically or become abstracted and simplified. The nature of the place may suggest rendering possibilities. Consider the topography, foliage, bodies of water, the weather—all physical aspects that make up a place. Scale will be an important factor in combining the elements. Think about whether your chosen landscape implies dense or sparse imagery. Color can be heightened or changed to create a specific mood. We are not interested in simply making a scale model but in integrating the concept with knowledge of sculptural and aesthetic elements of design and individual intuitive responses and concerns. Good craftsmanship is necessary so that you end up with a well-constructed piece that will not fall apart when carried about.

This sculpture should take on a special meaning for you. Make it a personal, secret space. However, the visual aspects should not only make the space meaningful to you, but interesting and strong as a sculptural form to others as well.

Related Artists*

Marcel Duchamp. *Boite-en-valise.* 1938–42.

*See also artists list for *Autobiography Box* problem.

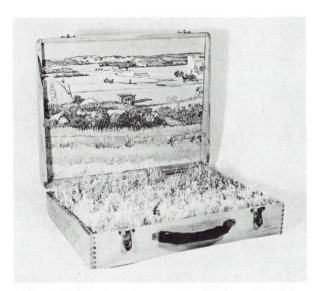

Tom Schneider. Mixed media: paint box, Van Gogh reproduction, dried grass.

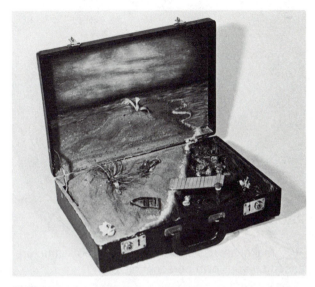

Patti Maloney. Mixed media: attache case, paper mache, sand, paint, found objects.

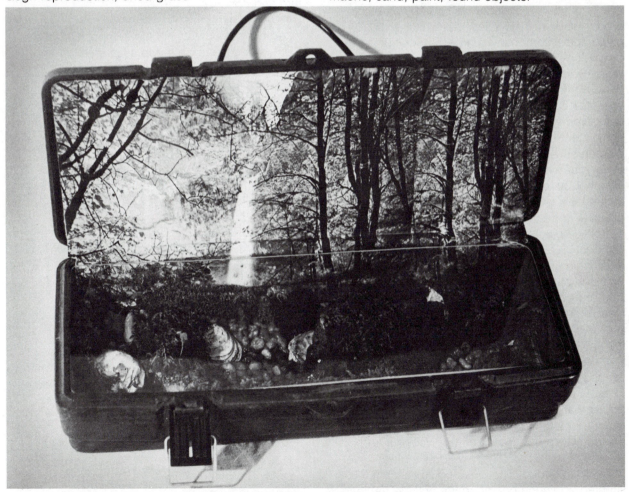

M. Z. Djazayeri. Mixed media: toolbox, photograph, plexiglass, rocks, water.

AUTOBIOGRAPHY BOX

From a problem by John Stewart.

PROBLEM:

Make an assemblage within a box structure based on your own personal history.

Use imagery based on concepts about the events of your own life as the source material for a box sculpture. The visual basis for the piece could come from many sources. Think about the chronology of the important events of your life. Where were you born? When did you grow up? What events were occurring in the world during your life? Consider the nature of the places you have lived in or visited, as well as your family and home life. Relationships and friendships with people can be an important source of information. Explore your feelings and fears. What is your profession, hobby, or special passion? Are you an athlete or a gourmet cook? Use aspects of your physical appearance or health. Documentation or symbolic objects are useful; consider using official documents or photos or mementos that are meaningful to you, or simulations of these things. Your sculpture could span the events of your lifetime or be based on a single incident or dream or meaningful memory. (Both of the accompanying illustrations are based on isolated incidents from the artists' childhoods.)

Begin to let both two- and three-dimensional images symbolize the parts of your life you wish to explore visually. Begin to gather images together that depict this information. Either construct a box form or use a found box. It could be a shadow box that hangs on the wall or a free-standing box. It could have a lid or a glass cover or be open ended. The piece could be constructed within the box or on the outside. Access to the box could be limited, such as using a peephole. The proportions of the box should be in keeping with the concept; it could be a cube or a long thin shape. The box, however, does not have to be a rectangular solid, but could be constructed in a shape that enhances the visual nature and concept of the piece.

A box structure is a confined space with definite boundaries in which the composition of elements will have to be made as interesting and *right* as possible. Consider using a formal, grid-like division of space, or structured modules that the images could work within, or a looser or more organic assemblage. Perhaps objects could shift and move about, or doors and smaller structures hide and then reveal images. Make many idea sketches and try all possible combinations before fastening the assembled information together.

While constructing this piece, remember that a literal translation of events and ideas is not at all important. Rather, the piece should be assembled with an eye to pure visual interest and mood. This assemblage is not intended to be merely an accurate historical fact-relating piece, but rather a sculptural image that draws upon your life and self as a basis for exploring your interests as an artist.

Related Artists

Joseph Cornell	Arthur Dove
Roland Reiss	Betye Saar
Robert Graham	Mary Beth Edelson
Max Ernst	Robert Hudson
Pol Bury	Robert Rauschenberg
H. C. Westermann	Louise Nevelson
Lucas Samaras	Robert Morris

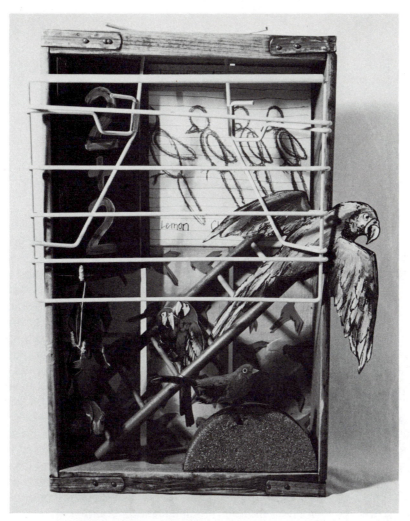

Karen Kelly Keltner. Mixed media.

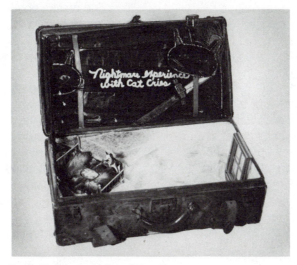

Patti Maloney. Mixed media.

MASK

PROBLEM:

Make a sculptural mask that expresses visually both your physical features and some aspect of your personality.

Masks have been used throughout history and in almost all cultures for disguise, protection, and impersonation or as a performance or ritualistic object. Masks are also sculptural objects that become fascinating in their basic relationship to the human form and their varied subject matter. Spend some time researching the masks used by tribes in central Africa, theatrical masks used in Japanese Nō drama, or Roman and Egyptian death masks. In this problem you will explore your own facial features, as well as your inner emotional self, to construct a mask that can be seen worn or on display as a sculptural object.

A mask, which is a partial cover for the face and head, could present a part of you that is not readily seen. Your face communicates certain aspects of your self to other people; use the mask to represent other, more hidden elements. Perhaps the mask could represent your alter-ego, or fantasy self. The manipulation of visual elements could change your moods and emotional expressions. A normally sunny, cheerful physiognomy could be changed to a snarling, vicious distortion of features, or vice versa. The mask could explore the darker or lighter sides of your personality, moods, insecurities, faults, virtues, and so on. A mask could reveal something, or it could hide something that you don't wish people to see. Use

this exploration of your individuality as a human being become the basis for your mask.

Make notes and idea sketches for combining your facial characteristics with certain aspects of your mental or emotional self. You could begin with actual casts of your face or of certain features. Or you could draw or Xerox your face, paint it, or sculpt it out of clay or papier-maché. You could begin to stylize your particular features or do caricatures. Think about abstraction, distortion, aging. The mask does not have to be symmetrical or face shaped. It could be fragmented, asymmetrical, with any contour or shape that you wish. The medium chosen and the style in which the mask is rendered will heighten the mood or emotional climate of the piece. Consider detail, decorative elements, and surface. The mask could have a painted surface or could simply become interesting through the surface of the chosen sculptural medium.

The mask should be designed so that you can wear it or hold it with some kind of device in front of your face. Consider designing the mask to incorporate a head piece or a structure that will fasten to the neck or upper shoulders. The mask must also become an interesting sculptural object when displayed away from your body; design some kind of display element. The mask could hang on the wall, be a freestanding object, or have its own display or carrying case.

Consider all aspects of your personality as a basis for the mask; combine visual elements representative of this exploration with your facial features and knowledge of traditional and historical mask forms to create a strong and intriguing art object.

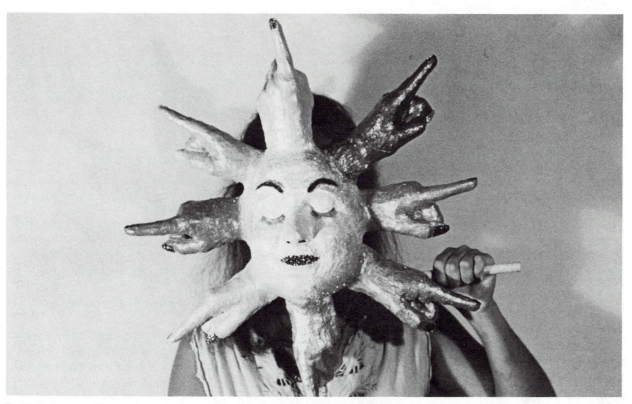

Patti Maloney. Plaster bandage, pearlescent acrylic, glitter, eyelashes.

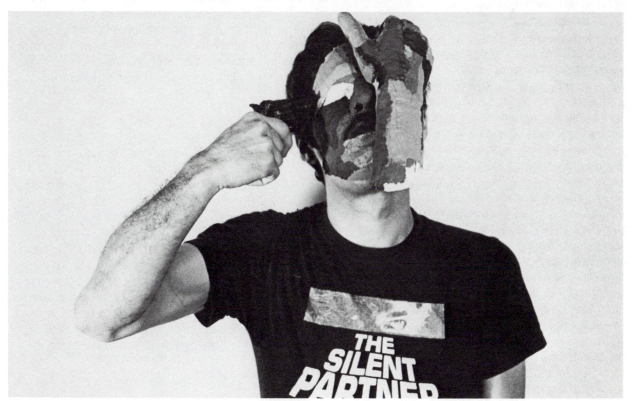

M. Z. Djazayeri. Plaster bandage, toy gun, gouache.

TENSION

PROBLEM:

Make a nonobjective sculptural object or installation that illustrates the principle of tension.

Tension implies stress and tautness. It could be thought of as a kind of precarious balance and imbalance between opposing forces. These forces are various: pushing, pulling, stretching, suspension, dominance. It also could imply threat or uneasiness. Tension seems to catch a moment in time; it implies that something will spring loose, or fall, or break at any moment.

Look around you and you will begin to observe tension almost everywhere you go: overhead electrical wires, seesaws in a playground, a slingshot, a cantilevered terrace on an apartment building, guy wires steadying a radio tower, stretched canvas in an artist's studio, bookends on a bookshelf, a bench vise in a machine shop, bridges, geodesic domes.

Begin this problem by making idea sketches that illustrate various ways of applying, or implying, tension. We can work with actual tension or visually portray a tense image. Design pieces that will pull forms apart or push them together. Think about a suspended object or a stretched, suspended installation piece. Juxtapose contrasting elements: rough versus smooth surfaces, a pointed object threatening a pneumatic form. Plan forms that feel precarious or are misbalanced. Refer to your list of sculptural materials. (See *Paper Relief* problem.) Begin picking out materials that would seem to be in keeping with the concepts explored in the drawings.

Certain materials will imply tension. Springs are a pushing device; turnbuckles pull and tighten. Vices and bolts apply pressure. Guy wires imply balance and support. Fabric or rubber bands can stretch and pull; wire and rope imply suspension or binding. A medium such as wood can work in many ways. When thin and supple, it will bend and flex; when heavy and thick, it is rigid and immovable and could be used in another way.

Remember that your piece can use actual tension in its construction or simply imply tension visually. We are interested in a formal, nonobjective use of materials to make a tense sculptural form. Do not solve this through use of an objective, narrative situation. Within this concept, you are free to use any sculptural medium or approach the problem from many different directions. Pay attention to all formal elements of composition and structure and craftsmanship to make a sculpture that strongly illustrates tension.

Related Artists

Kenneth Snelson
Mark DiSuvero
Donald Judd
Richard Serra
Ronald Bladen
Anthony Caro
David Smith
Robert Grosvenor
George Rickey
Alexander Calder
Guy Dill
Gordon Matta-Clark
Christo
Naum Gabo
Anne Healy
Beverly Pepper

Carol A. Munday. Masonite, wood, wire, spring.

Sherolyn Sisco. Wood, fabric, rope.

David Phillip Swartz. Wood, bolts.

BRIDGE FORM

From a problem by Sam Norgard.

PROBLEM:

Build a sculptural bridge form that spans a designated space or explores the idea of joining two things together.

Bridges are structures that span a space or allow access from one place to another. A bridge has connotations of spanning, extending, connecting, linking, tieing, uniting. It allows someone or something to traverse or pass over or cross to arrive at another place.

Explore all the possible structural and conceptual possibilities in bridges. Look at bridges, viaducts, overpasses, and tunnels. Begin to make sketches illustrating bridge forms. Think about *what* is being bridged; it could be physical space (the Grand Canyon) or a mental or emotional space (communication or generation gap). One solution to this problem was a bridge form that fit into the mouths of two people facing each other. This absurd object made a humorous and witty comment on human relationships and communication.

You could begin to devise a sculptural form or object that spans actual three-dimensional space such as a small creek or a sidewalk. One student built a squirrel bridge high in the trees. Think about the structure of bridges and their different designs. Look at the differences between a highly sophisticated bridge like the Golden Gate in relation to the creaking, suspension bridges that people are always getting into trouble with in movies. Use these aspects of bridges in an abstract way or as source material for a sculptural form. One beautifully crafted wooden tabletop object used the tension of a bent piece of wood and rubber bands to make a sliding platform move from one end of the structure to the other. It combined the structure of a bridge with the movable aspects of ferryboats or ski lifts.

You could also work two-dimensionally, in proposal form, for a bridge structure that involves an impossibly enormous space (Earth to Pluto) or for a place not in your immediate vicinity (an ice bridge at the North Pole). Work with drawings, writings, plans, blueprints, and maps to communicate your concept. This kind of idea could be presented in model form. One such model involved a cloth form with buttonholes that buttoned to the coastlines of California and Japan, spanning the Pacific Ocean.

Explore the concept of bridge forms as a basis for a sculptural object or proposal. Think carefully about structural and three-dimensional design, choice of materials, craftsmanship, composition, color, and so on. Make good use of all formal visual elements in combination with an interesting conceptual base to make a strong, sculptural bridge form.

Carol Costello. Styrofoam, clothes.

SOUND AND THREE-DIMENSIONAL FORM

PROBLEM:

Make a sculptural object or situation that somehow produces or incorporates sound.

In this problem, we are concerned with the combination of three-dimensional form or space with sound. There are many ways to approach this concept; here are just a few.

The most obvious, of course, is to make analogies to musical instruments. In this way you could make a sculptural object that has the potential to make sound, either musical or rhythmic. Begin by researching musical instruments and becoming aware of the principles on which they are designed. Musical instruments are visually gorgeous; they incorporate beautifully crafted, fine materials, and their three-dimensional form is fascinating. The design is determined by the kind of sound desired. This melding of form and function could be a starting point for this problem.

Work with a variety of media in constructing an object of this nature. You could use a found object as a starting point, or you could design it from new kinds of materials. One solution used a common garden rake mounted on a sounding box that echoed its shape, to make a kalimba-like instrument. Another solution that worked much like a tambourine was made with bits and pieces found in a plumbing supply store.

Another obvious direction to take would be to design a new-sounding instrument. One solution used rubber-tipped, spring doorstoppers mounted on a sculptural base. They twanged and vibrated when they were bent over and released; the motion of the springs added visual interest to the piece as well.

You could make an object that is not at all oriented toward a musical instrument, but rather makes a continuous sound that somehow relates to its visual quality. Robert Rauschenberg once incorporated two radios into a piece (*Broadcast*, 1959) that were tuned to two different stations. The visual objects were thus inseparable from their sound. The sculptor Robert Morris made a sculpture called *Box with Sound of Its Own Making,* 1961, in which he tape recorded the sound produced while he made the object and then incorporated this documentation as an inherent and inseparable part of the piece.

Artists have involved motion within sculptural electronic objects that react to the presence of a viewer with distinct and varied sounds. Performance artists use sound or music that enhance and are inseparable from the visual aspects of a piece. Indeed, the instruments used by Laurie Anderson and Charlotte Moorman provide the conceptual basis for their art.

Your piece could look like the sounds it makes. (See *Sound Pattern* problem in Section I.) For instance, the sculpture of George Sugerman, writhing, moving, be-bop shapes, has always felt sound-oriented to me. Even the subtle humming of Dan Flavin's fluorescent light installations becomes an inseparable part of the light quality and its activation of a particular space.

Consider all these aspects of sound-visual form relationships in conceptualizing a sculptural piece. Make many idea sketches and notes, considering appropriate media and your technical capabilities. Remember that sound is an important and inseparable aspect of the piece and that it should be incorporated within a well-planned, well-conceived sculptural situation.

Related Artists*

John Cage
Dennis Oppenheim
Joseph Beuys
Laurie Anderson
Charlotte Moorman
Robert Rauschenberg
Robert Morris
Jean Tingueley
Harry Bertoia
Arthur Secunda. *Music Machine.* 1964–65.

*See also artists list for *Video Sequence* problem.

M. Z. Djazayeri. Garden rake, wood.

Patti Maloney. Conduit, washers, coins, rubber bands.

TRAPS

From a problem by Mac McCall.

PROBLEM:

Build a better _____trap.

What is actually to be trapped in solving this problem must be determined by you. It is necessary to consider such factors as your location, what is a problem, things that you fear, what strikes your imagination, and how you feel about the ethical implications of traps in general.

This problem is based on Mac McCall's class at the University of Utah where students actually built mouse traps in an attempt to control a rodent problem in one of the buildings. At Florida State University, we decided to build shark traps, because, living on the Gulf of Mexico, we wanted to work with pieces that had to be activated in the water.

The problem can be approached in two completely different ways. The first is to explore sculptural form by actually building an object that will seriously attempt to catch something. The second is to propose conceptual sculptural solutions and to design an object or situation on paper. Because of obviously limited resources (and because we didn't really want to deal with the sharks once we caught them), we opted for the latter.

By conceptualizing solutions through proposals, we were able to come up with shark traps that were frankly improbable and endlessly fascinating to design. The students, freed from having to actually build and pay for a working trap, drew up proposals that were imaginative, free thinking, funny, and often rather breathtaking in scope and purpose. Here are a few examples:

A baited device floating in the water that, when swallowed, inflates automatically and floats the shark to the surface where it is picked up by a waiting boat and eventually deflated.

An underwater projection system showing the films *Jaws* and *Jaws II,* which lures sharks into a camouflaged cage.

An exclusive underwater shark elevator that whisks them to the surface and into the hold of a waiting ship.

A helicopter that dumps loads of bait fish with tiny metal parts in their tummies; a gigantic electromagnet on shore magnetically draws sharks who have eaten the bait and beaches them for later collection.

Another point in favor of devising traps conceptually is that it allows students free rein in designing an aesthetically interesting solution without actually harming the trappee. This problem raised issues of ecology and conservation and elicited fears and phobias. Some students devised peaceful, nonharmful solutions; others made terrifyingly bloodthirsty plans. This disparity caused animated discussion that became a valuable by-product of the learning process.

Proposals for three-dimensional works must be presented to the viewer in the strongest, most informative fashion possible. Even if the solution is a wild fantasy, it can be rendered two-dimensionally in a matter-of-fact way, as though it were possible. Use plans that tell the viewer what the piece looks like from all sides, top, and bottom, maps locating specific sites, photos, diagrams, plans, installation drawings, and specific writings indicating how the trap should work. The major element of this problem is conceptualization; however, the visual design must be as strong and clear as possible.

Related Artists

CONCEPTUALISTS:

Joseph Kosuth	Douglas Huebler
On Kawara	Dennis Oppenheim
Ian Burn	Gilbert and George
Robert Barry	Bernar Venet
Iain Baxter	Lawrence Weiner
Mel Bochner	John Baldessari
Daniel Buren	Shusuku Arakawa
Jan Dibbets	Bruce Nauman
Hans Haacke	

Diana Paver. "Proposal for a Shark Trap."

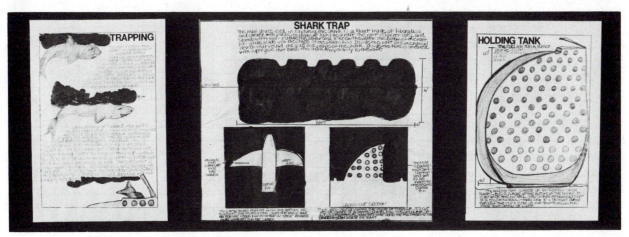

Laura Blank. "Proposal for a Shark Trap."

SITE-INSTALLATION PIECE

PROBLEM:

Design and build a sculptural installation conceived for a specific site or space.

Site sculptors or artists whose work is installed in a particular space are interested in using three-dimensional form that goes beyond simply placing a sculptural object within a gallery or museum. Many artists are building pieces that interact with the earth or natural sites as well as activate spaces within an architectural space. Let the concept of interrelationship between sculptural form and the space in which it is to be seen become the basis for this problem.

Become familiar with artists who have explored site sculpture. (See the accompanying list of related artists.) Robert Smithson used the materials at hand to build his huge *Spiral Jetty*, 1970, at Great Salt Lake, Utah. Christo's immense project, *Running Fence*, 1976, used supported fabric to make an incredible undulating fence form activated by wind and light and determined by the nature of the land that made us aware of the contours of the earth's surface. Michael Heizer's monumental desert pieces become man-made monolithic architectural structures that interact with landscape and sun.

Gordon Matta-Clark's work involves taking slices or wedges out of the middle of buildings, cleanly exposing the structure and opening the space. Judy Pfaff's installations are a combination of paintings on the walls and echoing three-dimensional forms designed specifically for particular interior spaces. Dan Flavin uses light to affect our perception of an enclosed, architectural space.

Using simple materials, do an installation that utilizes a chosen site in nature or within an architectural space. Your piece must be determined largely by the size, scale, and visual characteristics of the site. Spend some time in the site simply observing and absorbing the nature of the space. Consider the elements within the space, such as color, light quality, and the objects and surfaces found there. Think about enhancing, negating, or echoing these elements.

Examples of installations are the following:

A clean rectangular plot of grass was punctured with a grid system of fine, shiny wire forms, making a neat analogy between the rectangular shape as well as the nature of the short blades of grass.

An artist shot Polaroid photos of every detail of an interior courtyard, built a model with a mosaic surface of the reproduced information, and put the tiny model in the center of the space. It was especially interesting because the walls of the courtyard were around the viewer, but the model was a rectangular solid with the photo information on the outside of it; the viewer stood *inside* a box looking at the same information on the *outside* of a box.

A long, undulating rain gutter was bridged by hundreds of repetitive rhythmic pieces of bamboo cut and wedged into place.

A dark, dank concrete recess in the outside of a building had a startling rectangle of sunny blue sky high on one of its walls, reflected by an installed mirror.

Consider the concept you wish to convey within a chosen site. Make many sketches and notes and consider differing media. Make the viewer aware of what it is that you are saying about the space, while creating interesting form-space analogies. Meld the characteristics of a chosen site with your sculptural interests to make the most involving site-installation piece possible.

Reference

HOLT, NANCY, ED., *The Writings of Robert Smithson*. New York: New York University Press, 1979.

Related Artists

Walter de Maria	Michael Heizer
John Pfahl	Douglas Huebler
Robert Erwin	Richard Serra
Gordon Matta-Clarke	Mary Miss
Mario Merz	Anne Healy
Daniel Buren	Alan Saret
Dan Flavin	Nancy Holt
Michael Singer	Charles Simmons
Judy Pfaff	George Trakas
Christo	Lloyd Hamrol
Robert Smithson	Robert Morris
Dennis Oppenheim	Joseph Beuys
Jan Dibbets	

Betsy Eichelberger. Styrofoam and cord.

Christine Karas. Cardboard boxes on glass.

WIND

PROBLEM:

Make a sculptural object or create a situation that somehow incorporates moving air.

In this problem we will create a sculptural object, situation, installation, activity or performance, documentation, or conceptual proposal that involves wind or moving air. Wind is invisible to the eye; we sense its presence by feel, smell, and sound. Wind does, however, become visible when it activates, or moves, something—trees, dust in the street, waves at the ocean, or clouds in the sky. Begin this problem by simply observing wind and how we become aware of it. Look at everyday objects that relate to moving air: weathervanes, flags, kites, hang gliders, sailboats, wind-velocity measuring devices, weather balloons, parachutes, wind socks at airports, fans. You could also think about creating wind by moving yourself through still air, such as driving a fast car down the road or riding a bicycle.

Make notes and sketches of as many ways as possible to activate a sculptural piece with moving air. It could start as a stationary object that becomes kinetic when the wind blows; a piece of this nature involves wind direction and velocity. It could have frenetic motion that is very complex. It could illustrate a large movement, as in George Rickey's graceful, balanced sculpture, or a gentle, changeable motion that can be observed in Calder's mobiles. A sculptural form could be made of fabric that would open, fill, flicker, wave, soar, fly, or billow. It could become a piece designed to stop the wind, a wind break. You could explore weather and the meteorological aspects of wind. Something like steam or smoke or a fine powder could make moving air visible momentarily.

A fantasy piece could be conceptualized and presented in proposal form. One solution involved a cable stretching from Alaska to California. An object designed to be pushed by the wind moves along the cable. At various selected points, the moving object strikes and releases parachute packs containing fireworks that activate and float slowly down into the sea.

Consider all these concepts in devising a three-dimensional solution that illustrates or is activated by moving air. Make a strong visual statement that communicates your concept clearly by making thoughtful use of your materials, formal elements, visual vocabulary, and presentation.

Related Artists

Alexander Calder
George Rickey
Christo
Anne Healy
Otto Piene
Andy Warhol
Len Lye
Hans Haacke
Dennis Oppenheim

Darlene E. Chenevert. "Proposal for a Wind Piece."

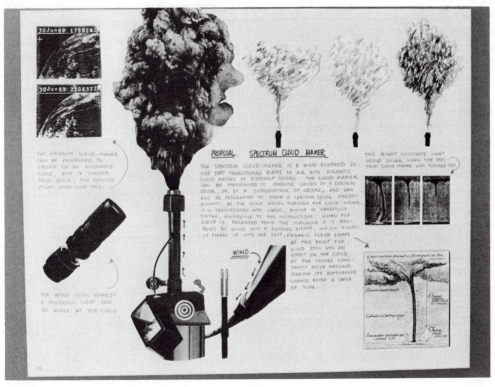

Elizabeth MacLean. "Proposal for a Wind Piece."

WALL-CEILING-FLOOR

From a problem by Lou Ocepek.

PROBLEM:

Create a three-dimensional object or installation that makes visual sense in the 90-degree angle between ceiling and wall, wall and wall, or wall and floor.

In this problem we will be exploring the concept of visual connection. The wall-ceiling-floor planes in architecture make right-angle corners where they meet, which we will use as sites to explore sculptural form. The form will be an installation piece that will fit into a chosen space and activate, or make sense of, a particular 90-degree angle corner.

You may use any medium on this problem by referring back to the list of one hundred sculptural materials that you made in the *Paper Relief* problem and considering the potential of materials that interest you. The medium may suggest form when thought of in relation to the problem. Choose a space that interests you, thinking about the light quality, wall-floor-ceiling surface and color, the proportions of the space, traffic patterns of the building, and so on. Do many idea sketches for each of your medium preferences.

There are many ways of approaching the problem. You could simply fill in a corner space, as one beautifully shaped corrugated cardboard piece did, floating high above us in a wall-ceiling angle. Another piece connected the planes of two walls with a styrofoam piece painted cleverly to look like steel girders bursting out of one wall and just as abruptly disappearing into another. Another solution dealt with the light quality of a site by using cloth forms hung from the ceiling that became more and more transparent as they got closer to a window wall. Another wood piece had multiple, adjustable linear forms that danced together and made crazy angular relationships within the 90-degree angle of the site.

Make the characteristics of a given architectural site interact with and determine the nature of the material you use. Try to activate the space of the site as well as make visual sense between two architectural planes. Use a strong manipulation of materials and good craftsmanship combined with these spatial concepts to make a strong sculptural installation.

Related Artists

Lucas Samaras. *Room #2.* 1966.
Robert Morris
Robert Irwin
Dan Flavin
Eva Hesse
Don Judd
Judy Pfaff
Keith Sonnier
Mario Merz

Larry Orchard. "Cardboard and Concrete."

Oscar Recalde. Styrofoam, paint, rivets.

Vicki Harrell. Hose, faucets.

Chris Hiller. Wood lattice, bolts.

DANGER

From a problem by Tommy Mew.

PROBLEM:

Make a sculptural object or situation that implies danger.

The day we installed the solutions to this problem around the building, people became extremely upset. Even though they were in no actual physical danger (remember, the problem is to *imply* danger), they felt threatened and menaced. This made us as happy as clams. The viewers' responses and reactions to the visual aspects of the problem were just what we were hoping for.

Danger means risk, peril, hazard, jeopardy, insecurity. It is possible to solve this problem by making an objective or narrative situation or setup of found or constructed objects that would imply a dangerous situation. One solution was a huge, flat, padded sculptural shadow figure lurking strategically against the wall behind a door. Another involved chalkmark outlines of many figures (it looked like a massacre had just occurred) strewn across a carpted lobby complete with chalked notes pertaining to each person's vital statistics.

Danger can also be implied with abstracted or nonobjective form. In a stairwell, pointed at an angle straight at me as I opened the door, was a massive, black structure of beveled, pointed wooden beams. It was definitely a disquieting suspended object. Outside the building, a huge, tentacled, monsterlike form crept quietly out of the ventilation shaft and up the walls of the building. Walking down a narrow corridor, one was confronted with three big "explosions" on pedestals, built of Styrofoam, painted in Day-Glo colors and black in rough brushstrokes.

Begin by thinking about fears. Make lists of objects or situations or stories that scare you. Consider phobias and insecurities. Begin to think how you could illustrate a dangerous situation or combine these fears into a seemingly dangerous object. Refer back to the list of sculptural materials made in the *Paper Relief* problem. Consider making images look harmful by using benign materials that you have manipulated skillfully to *appear* to be dangerous. Think about found objects, as well, that could be combined in some kind of installation or assemblage.

Consider your viewer's response. We want the viewer to feel something, to react, but remember that it is very easy to solve this problem by simply disgusting someone. Avoid cheap shots. Try to make a piece that solves the problem with intelligence and wit and is interesting sculpturally as well.

Related Artists

Edward Kienholz
Lucas Samaras
Richard Serra
Chris Burden
Vito Acconci
George Segal
Dennis Oppenheim
Walter de Maria
Bruce Choa

David K. Manley. Metal, wood, Spanish moss. "Hard-hat, flit gun."

Michael Bath. Found metal objects.

FURNITURE

PROBLEM:

Transform an actual piece of furniture into a sculptural object or situation.

Furniture, functional objects that make life more comfortable, is usually thought of in terms of design function and appearance, human comfort, utility, and decorativeness. This problem, however, draws attention to furniture presence, use, and visual interest to stimulate ideation or to provide a basis for constructing a sculptural object. Furniture is used daily, and its presence taken for granted; pieces of furniture are just *there,* waiting to serve, mute witnesses to human events. Think of a piece of furniture as a springboard to further sculptural concepts. Perhaps it could be thought of in a loose narrative sense: a bed evokes different imagery than does a kitchen table.

The key word in the problem statement is *transform.* Look up the definition in any good dictionary. Basically, the word *transform* has, for our purposes, three meanings:

metamorphose: to change completely or essentially in composition or structure.
alter: to change the outward form or appearance of something.
convert: to change in character or condition.

Begin by looking at furniture in your living space, stores, junk stores, in the garbage, and at the dump. Look at furniture in places that have widely differing functions (a sleazy beer hall versus a doctor's office). Think about the relationship of furniture to a place's atmosphere or ambiance. Make lists of furniture, all the different kinds there

are. Think about the inherent possibilities of each piece and choose an object for the problem.

Think about ways of transforming an object into something else: distortion, embellishment, repetition, decoration, change or negation of function, camouflage, change of form, proportion, color, texture, media. One of my students made an analogy between furniture and the people who use it by making a cast of her nude body seated and combined it with a chair. When someone sat on the chair, the person was sitting on her cast thighs, with the cast torso supporting the back and the arms providing chair arms. (When I asked the student if the chair wasn't incredibly sexist, she pointed out how uncomfortable it was to sit in.)

Consider specific ways of attacking the piece sculpturally and what tools and materials you have available. An object may need to be placed within a particular context; consider the possibilities of a sculptural installation built around a piece of furniture. The piece could have an autobiographical solution or could set up a narrative. There are many ways of raising the piece of furniture from a functional to a sculptural level. Work with words and sketches, considering all conceptual possibilities before actually beginning to work with the piece.

Related Artists

Richard Artschwager	Margaret Wharton
Robert Rauschenberg	Mary Stoppart
Lucas Samaras	Allen Jones
Jim Dine	H. C. Westermann
Claes Oldenburg	Kurt Seligman
Richard Shaw	Paul Harris
Roland Reiss	Edward Kienholz
Scott Burton	George Segal

Ginger Serven. Highchair, wood, paint.

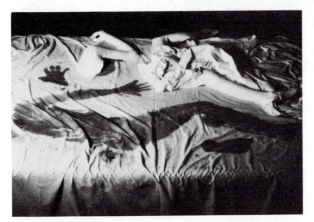

Rick Lurding. Bed, fabric, plaster, paint.

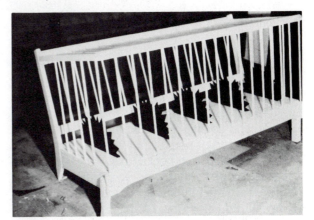

Kimberly Evenson. Sofa, wood, paint.

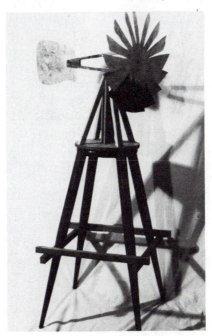

'Sparki' Corbin. Stool, sheet metal.

ARMOR

PROBLEM:

Design and build a wearable suit of personal armor.

Although animals such as armadillos, turtles, crabs, and oysters are provided naturally with a carapace of protection, the human body has to be protected against all sorts of dangers. Knights, warriors, and soldiers have, throughout history, worn some kind of personal physical protection. In sports, football and hockey players wear defensive safeguards to keep their bodies from harm. The twentieth century has forced the development of specialized kinds of armor for survival such as astronauts' life-support systems and nuclear plant workers' shielding suits.

In this problem, however, we will use armor not only as physical protection but as an emotional or mental defense as well. The reason for making a personal suit of armor should come from very personal concerns, such as fears, anxieties, insecurities, phobias, or faults. Armor can be made to protect you symbolically from broken hearts, sexism, illness, fear of being alone, insecurities about physical appearance, or boredom. Armor can provide privacy, aggressiveness, anonymity, fantasy, shelter, and confidence.

This problem requires some self-exploration. You must think about what you want to fight against, what frightens you, or what you need protection from. It is up to you to analyze these concerns, decide which are the most important

for you to explore, and decide which have the best inherent visual possibilities.

At the same time, make a list of simple media such as foam rubber, papier-maché, cardboard, vinyl, wood, found objects, and so on. Through drawing, begin combining specific media ideas with your personal concerns, considering the properties of your chosen medium as well as form, proportion, fastening systems, and wearability.

As you build the armor, fit it to your body. Think about relevant accessories such as weapons, shields, or helmets. Build the armor so that the form, details, surfaces, and color all work together to make your particular defensive purpose clear.

Next, design some kind of situation in which the armor can be displayed when it is not being worn. Because it is essentially sculptural, a kind of rigid exoskeleton rather than just clothing, armor can be interesting as a three-dimensional object in itself. The armor could hang on the wall in bas-relief fashion, fit into a special case or box, be supported by some kind of framework, or become part of a larger sculptural environment.

The major concern of this problem is exploring sculptural concepts that relate to the human body, using armor as the vehicle. The content of the armor must come from plumbing your emotions and thinking. The process of synthesizing these concepts through your personal aesthetic should help to clarify and strengthen your perception of yourself as an artist.

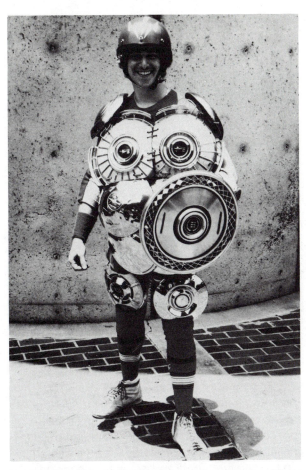

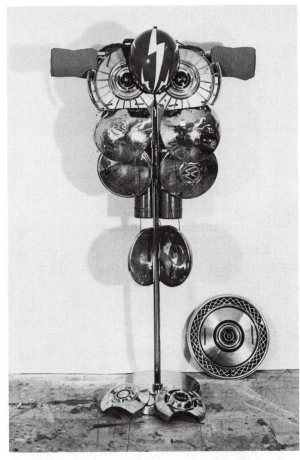

David Marc Fried. Hubcaps, cord, costume. (On artist's body)

David Marc Fried. Hubcaps, cord. (On display)

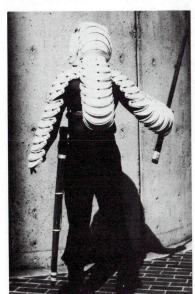

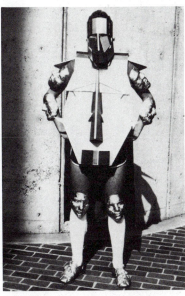

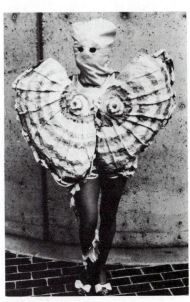

Henry Villarama. Motorcycle helmet visors, costume.

Tim Copeland. Foam-Core, plaster bandage, costume. "Never-Alone Man."

Barbara LaPointe. Paper mache, paint, fabric.

PERSONAL SHELTER

PROBLEM:

Build a small personal shelter that also becomes an interesting sculptural space and form.

Shelter traditionally provides protection and cover from the elements. It can be as simple as a tarp thrown over a line to make a tent or as glossy as a Las Vegas hotel. Shelter is the basis for architecture. The line between architecture and art often becomes very fine. Many artists have explored architecture as a basis for their work: consider Michael Heizer's huge *Complex One/City,* 1972–1976, in the Nevada desert, Christo's *Running Fence,* 1976, Alice Aycock's wooden fantasy structures.

We are interested, however, in constructing a *personal* shelter. Begin to consider what kind of place makes you feel good, or boosts your ego, or makes you comfortable. You could think of a shelter that would provide things other than physical protection; personal fears and insecurities could provide a basis for this problem. It could be related to architecture as we know it, architecture throughout history, or architecture of other cultures (yurts, nomad tents). Begin to think about animal shelters such as burrows and nests and cocoons. It could be a fantasy place (clouds, the Emerald City of Oz), or it could be related to a specific place other than where you actually live.

Refer to the list of sculptural materials made in the *Paper Relief* problem. Begin to consider a specific material as a way of conceptualizing the notion of shelter. One solution involved the use of polyester quilt-stuffing material that was formed and sewn into a fluffy, suspended cloud form. The light quality in this piece was amazing; a kind of pearly, translucent peacefulness pervaded the interior. Another solution involved a cocoon-form integrated into a climbing tree high above the ground. It was made of heavy white felt and was lashed and intertwined to the branches with ropes to form an enclosing sculptural space that fit the artist's body perfectly.

Unless your personal shelter is based on the need to have a lot of people around, try to work fairly small and make a space just for you. It could be an independently movable piece that can be carried about easily or integrated into a specific site. Make the best possible use of your chosen medium; construct your shelter with an eye to sculptural form and constantly consider elements of three-dimensional design, composition, construction, structural form, craftsmanship, surface quality, and color. Shelter implies both interior space and exterior form; these are obviously inseparable, and you will have to make both interior and exterior as visually interesting as possible.

Related Artists

Alice Adams
Alice Aycock
Christo
William Cristenberry
Gordon Matta-Clark
Donna Dennis
Jackie Ferrara
Red Grooms
Michael Heizer

Cletus Johnson
Michael McMillan
Roland Reiss
Charles Simonds
David Smyth
H. C. Westermann
Claes Oldenburg
Raphael Ferrer
Lucas Samaras

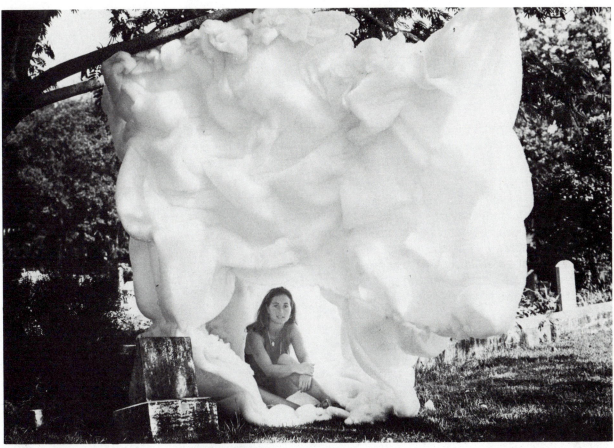

Patti Maloney. "Cloud Made from Dacron Stuffing and Cord."

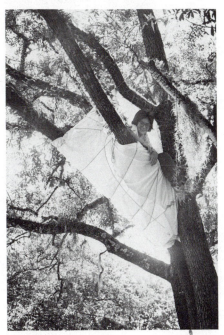

Elizabeth Newkirk. "Cocoon Made from Felt and Rope."

SELF-PORTRAIT

From a problem by Willem Volkersz.

PROBLEM:

Make a full-sized, mixed-media self-portrait.

In a time of art history when it is becoming more and more difficult to make art that is in some way unique and innovative, it is of utmost importance that you begin to value yourself—your peculiar perceptions and aesthetic—as a singular, totally one-of-a-kind entity. This awareness must be at the root of the art-making process, no matter what creative direction you choose to move into.

In this collection of problems, we have experimented with many concepts and materials in an effort to try to help you become a thinking, self-explorative image maker. These problems and activities were designed to make you more aware of your uniqueness as a human being/artist and at the same time to allow you a glimpse into the thinking and aesthetic processes of others. This problem is about exploring yourself, your history, your thoughts and interests, through the use of physical representations of your body. Use the intuition and knowledge of concepts and media and visual vocabulary gained to make a full-sized mixed-media representation of yourself within a loose self-portrait format.

Collect visual information about yourself. It should make reference to both your physical appearance as well as to your identity as an individual. Make drawings of your feet, cast your torso in plaster gauze, do a painting of your eyes, get hold of X-rays of past injuries, Xerox your buttocks, photograph yourself or write home for baby pictures, make body prints directly from your skin, make fingerprints and toe prints, sculpt your nose out of clay, cut your hair and save the cuttings, bring in favorite elements of your clothing or seek out fantasy costumes, use found objects that make relevant analogies to your body parts, keep a journal, or use words or typography. Become immersed in the process of representing your physical self in as many different ways as you can.

Begin to assemble all this information in a bas-relief on a wall surface, or into a freestanding figure, or a reclining figure on a horizontal surface. Use the gathered information to try to put across a sense of yourself as an individual; channel it through your personal aesthetic. Think about background imagery or supporting material. Let your body move into differing positions or be doing something. In solving this problem, one figure—half-human, half-robot—seemed to be breaking through a brick wall. Another was strung up like a puppet from puppet masters' controls and lines. A chicken wire and plaster cast form seemed to be caught in the process of shattering apart, spilling out the official paper documents representative of the artist's life activities. A figure intimated in bas relief by cast body fragments was mounted on an obsessive grid system of photobooth self-portraits. A projected slide superimposed a photographic image of the figure in the same position on the stark white three-dimensional representation.

All the elements of design and visual vocabulary and media exploration are, at this point, becoming an intuitive part of your art-making approach. Make the strongest possible representation of yourself that will communicate to the viewer something about who you are as well as make an engaging and significant art statement.

Related Artists*

William T. Wiley
Frida Kahlo
Bruce Nauman
Robert Morris
Mary Beth Edelson
Faith Ringgold

Betye Saar
Robert Arneson
Dennis Oppenheim
Vitto Acconci
Chris Burden
Joseph Beuys

See also Color Plate 25.

*See artists lists for *Found Object Figure* problem and *Biographical Relic* problem.

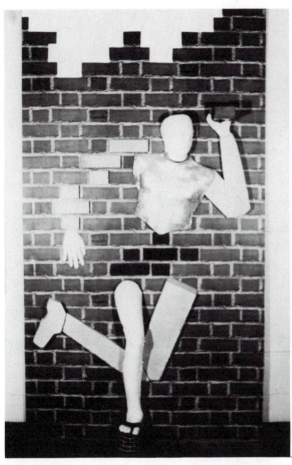

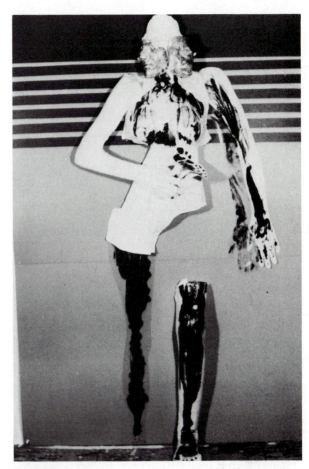

Oscar Recalde. Contac paper, wood, plaster bandage, styrofoam, paint, flip-flop.

Lisa Etheridge. Body prints on acetate, plaster bandage, paint.

Petie Brown. Xerox images, plaster bandage, clothing, paint.

Glossary

abstract, abstraction: The visual simplification, distortion, or rearrangement of an objective, recognizable thing or image.

academic: A term describing art that originates from a rigid set of visual rules rather than from individual intuition, exploration, or self-expression.

additive: 1. descriptive of any sculptural technique in which a piece is built up by adding materials 2. The additive primary colors in light are red, blue, and green, which blend to make white.

aesthetic: pertaining to artistic vision, interest, or experience

afterimage: Certain parts of the eye become tired when focused fixedly on any given color for a period of time. When the fatigued eyes are then turned toward a blank surface, the complement of the color *(afterimage)* is momentarily perceived.

amorphous: A visual image that is indistinct or not clearly defined.

analogous: colors that are next to each other on a standard color wheel

approximate symmetry: When a piece is divided by an imaginary vertical axis, the elements on either side are similar but not identical.

assemblage: sculptural form made by combining found objects and images together

asymmetrical balance: When a piece is divided by an imaginary vertical axis, the elements on either side are not in any way similar.

balance: A state reached when opposing elements become harmonious or integrated in a state of equilibrium within a composition.

bilateral symmetry: When a piece is divided by an imaginary vertical axis, the elements on either side are mirror images of each other.

biomorphic: organic, irregular shapes relating to nature

casting: a sculptural process that involves pouring a liquid medium such as molten metal into a mold where it hardens into the desired form

chiaroscuro: the two-dimensional rendering of light and shadow to imply a specific light source

chroma: a quality of color that refers to hue and intensity

collage: A piece created by fastening or gluing down pieces of paper, fabric, found images, etc. to a two-dimensional picture plane. (See *assemblage*)

color wheel: Colors are arranged in circular fashion according to their ordered specific relationships. The primary, secondary, and tertiary colors on a standard color wheel move around the circle in this order: red, red-orange, orange, yellow-orange, yellow, yellow-green, green, blue-green, blue, blue-violet, violet, red-violet.

complement: Complementary colors are those which are directly opposite on a color wheel. For instance, on a standard color wheel, red and green are complements.

composition: the ordering, arrangement, and interrelationship of all of the visual elements within a piece of art

concave: the recessed areas in a form that curve away

concept: the general idea determining the various elements and media in a piece of art

conceptualization: the process of conceiving ideas; the ability to mentally "see" visual images

content: the concept, idea, meaning, or message manifested within a piece of art

contour: a boundary line that separates form from background, or a three-dimensional shape from actual space; the outline of an object's outer shape

contrast: differences or disparity between visual elements

convex: the advancing areas in a form that bulge out

craftsmanship: the skill and style with which an artist manipulates a medium

curvilinear: a form composed of curved, rather than straight, lines

design: the overall basic concept, organization of elements, and manipulation of media within a piece of art

distortion: the twisting or manipulation of the character or visual appearance of an image

dominance: Certain elements of a composition that are more important than others are said to be dominant.

elements: lines, shapes, images, colors, etc. that make up a piece of art.

figure-ground relationship: a shape or image *(figure)* within its surrounding background *(ground)* on a two-dimensional picture plane

form: 1. a shape or contour of something 2. the overall design or organization of a piece of art

formal: Formal design elements are all those things listed within this glossary that make up any visual piece of art.

found images, objects: two-dimensional images or three-dimensional objects whose origins lie outside the realm of fine art: A postcard or family snapshot, a broom or a chair, are objects that were not originally designed and made to be art objects, however, they could conceivably be incorporated into a piece of art.

fourth dimension: The fourth dimension (in addition to length, width, and depth) is time.

geometric shapes: shapes dictated by the laws of geometry, such as circles, triangles, or squares

graphic: Graphic arts are those that exist on a two-dimensional picture plane.

grid: a space divided into a system of horizontal and perpendicular lines or geometric shapes

hard-edge: refers to forms with clean, even, definite edges

harmony: the unification of all the visual elements within a piece of art

hue: the name of the pure state of any given color within a standard color wheel or the spectrum

ideation: searching out all the possible solutions to a problem or goal; the process of generating ideas

illusion: a visual deception that causes the perception of reality through an artist's manipulation of the elements of visual language

image: the form, shape, object that is made tangible and viewable by an artist's manipulation of a visual medium

imbalance: when elements within a piece are not harmonious, are ill-at-ease with each other, or cause tension

intensity: the purity or saturation of a color (degree of brightness or dullness)

in-the-round, freestanding: a three-dimensional piece of art that can be viewed from all sides: It could be sitting on the floor, on a base or sculpture stand, or be suspended.

intuitive: applying a personal, instinctive sensibility to the process of making art rather than following existing standards or rules

line: the moving point made with a pencil or pen or any artist's tool on a surface

linear: refers to art that is expressed through line rather than mass or solid form

local color: the color of actual objects

luminosity: the effect, whether real or an illusion, of radiating light

medium, media: the materials that artists use to make art; sculpture, for instance, encompasses many different media; wood is just one sculptural medium.

mixed-media: a piece of art that combines several different media together

modeling: In two dimensional art, modeling refers to the use of light and shadow to make an object appear to be three-dimensional. In sculptural terms, modeling is the actual manipulation of some kind of plastic medium.

module: one unit in a system, or repetition of like visual elements

monochromatic: refers to one color or hue and its varying intensities and values

montage: several separate images combined together to form a composite whole

motion: realistically static art that gives the illusion of movement

multiples: the same image or object reproduced several times

narrative: art that has a story-telling element or purpose

negative space: the ground, field, or empty space left around a positive shape

neutral: Neutral colors are those greys or tans that cannot be associated with any specific hue color.

non-objective: that which is imaginative, from the artist's invention, and which has no reference to actual objects or things

non-representational: See *non-objective.*

objective: the rendering of known objects or facts

organic, amorphous, biomorphic: loose, irregular shapes that make reference to the forms found in nature

overlapping: images that are in front of or behind each other either illusionistically or in reality

palette: 1. can refer to a range of colors used by an individual artist or found in a specific piece of art 2. A palette is also the surface on which paints or inks are mixed.

pattern: obviously emphasized visual relationships; the repetition of forms or images in an ordered system

perception: the use of mind and eye to look, see, and collect all kinds of information

perspective: the use of visual elements to create the illusion of three-dimensional space on a two-dimensional picture plane

picture plane: flat two-dimensional surfaces (a piece of paper, canvas, a wall) on which an artist works

plane: a two-dimensional, flat surface

plastic: refers to the three-dimensional aspects of images (either real or illusion) or the ability of a medium to be molded and changed: Plastic, as a spatial term, refers to length, width, and depth.

pointillism: the process of making an image through many tiny dots on a two-dimensional picture plane

polychromatic: many-colored

positive space: the enclosed areas that are the shapes or images an artist means to communicate

primary colors: In pigments, red, yellow, and blue are the three hues from which other colors can theoretically be made.

proportion: the relationship or comparison of two or more images in terms of size, weight, emphasis, etc.

radial symmetry: symmetrical circular balance of elements extending from a center point

rectilinear: shapes that are composed of straight lines

reductive: refers to techniques in which a material is taken away: if one is carving away areas of a block of styrofoam, one is said to be working reductively.

relief, bas-relief, haut-relief: Bas (low) relief and haut (high) relief refer to three-dimensional work that extends off a two-dimensional surface.

render: to represent things as they actually are as accurately as possible through a visual medium

repetition: the same visual elements repeated over and over

representational: work that makes reference to the actual world

rhythm: the flow or reoccurrence of regulated visual elements

rubbing: the intimation of an actual texture made by pulling some kind of drawing medium across a piece of paper placed on a textured surface

saturation: See *intensity*.

scale: measuring the size and weight of a visual element; a comparison of the size and weight to something known and recognizable

secondary colors: In pigments, orange, green, and violet are the secondary colors that can be made by combining the primary colors.

serial imagery: images that form a continuum or inter-relationship with each other

shade: 1. the area of a form that is in shadow 2. colors made by mixing a hue color with black

shape: the contour of a figure and the area defined within; shapes can be made with line, or the area of a particular shape can be defined by visual contrast with its surrounding background space.

silhouette: an image (usually objective and recognizable) defined by contour outline solidly filled in with a flat black or color surface

space: See *two-*, *three-*, and *four-dimensional*, and *plastic*. Shallow space is a limited space or depth within a two-dimensional picture plane. Deep space is an illusion of infinite space depicted within the picture plane.

spectrum: A beam of light refracted through a prism forms a distinctive band of hues called the spectrum. These hues appear in the following order: red, orange, yellow, green, blue, indigo, and violet.

style, stylization: the manipulation of images through a particular medium so that the artist's individual character and communicative intentions are evident

subject matter: what a piece of art is about; what it depicts as expressed through an individual artist's sensibility

subtractive: See *reductive*. Also, the subtractive primary colors in light are cyan, magenta, and yellow.

surface: the exterior texture of a piece or the visual quality of a particular medium

symmetrical balance: When a piece is divided by an imaginary vertical axis, the elements on either side are identical.

synergy: In visual terms, synergy refers to images that together are much stronger and more interesting than each single image is by itself.

tactile: refers to the sense of touch; something that can be sensed by actually feeling it

technique: the particular way in which an artist manipulates a medium in order to produce a piece of art

tension: balance or inbalance, stress, action and reaction, or forces existing between the elements of any given visual organization

tertiary colors: In pigments, red-orange, yellow-orange, yellow-green, blue-green, blue-violet, and red-violet are the tertiary colors that are made by combining primary and secondary colors.

texture: The tactile, feelable surface quality of an object is referred to as actual texture. Simulated and invented textures are two-dimensional representations or intimations of tactile surfaces.

three-dimensional: an object that has length and width as well as depth or thickness

tint: any hue color that is lighter than its normal value; tints are made by adding white to a hue color.

triad: any three colors on a standard color wheel that are equidistant from each other

trompe-l'oeil: a fool-the-eye painting technique in which objects are rendered on a two-dimensional surface so painstakingly that the painting may be mistaken for reality

two-dimensional: a surface having length and width, but no depth

typography: the style, design, arrangement, and composition of printed words

value: the quality of lightness and darkness

volume: a three-dimensional form, or one that gives the illusion of weight or mass

Bibliography

DESIGN AND COLOR:

ALBERS, JOSEF, *Interaction of Color*. New Haven: Yale University Press, 1963.

BEVLIN, MARJORIE ELLIOTT, *Design Through Discovery* (3rd ed.). New York: Holt, Rinehart & Winston, Inc., 1977.

BIRREN, FABER, *Color Perception in Art*. New York: Van Nostrand Reinhold Co., 1976.

BIRREN, FABER, ed., *Itten: The Elements of Color*. New York: Van Nostrand Reinhold Co., 1970.

ELLINGER, RICHARD G., *Color Structure and Design*. New York: Van Nostrand Reinhold Co., 1980.

HANKS, KURT, LARRY BELLISTON, AND DAVE EDWARDS, *Design Yourself*. Los Altos, Ca.: William Kaufmann, Inc., 1977.

HARLAN, CALVIN, *Vision and Invention: A Course in Art Fundamentals*. Englewood Cliffs, N.J.: Prentice-Hall, Inc., 1970.

ITTEN, JOHANNES, *The Art of Color*. New York: Van Nostrand Reinhold Co., 1974.

KELLY, J. J., *The Sculptural Idea*. Minneapolis, Mn.: Burgess Publishing Co., 1978.

KRANZ, STEWART AND ROBERT FISHER, *Understanding Visual Forms*. New York: Van Nostrand Reinhold Co., 1976.

LAUER, DAVID A., *Design Basics*. New York: Holt, Rinehart & Winston, Inc., 1979.

OCVIRK, OTTO G., ROBERT O. BONE, ROBERT E. STINSON, AND PHILIP R. WIGG, *Art Fundamentals: Theory and Practice* (4th ed.). Dubuque, Ia.: Wm. C Brown Company, Publishers, 1981.

VISUAL THINKING, PERCEPTION, PROBLEM-SOLVING:

ADAMS, JAMES L., *Conceptual Blockbusting: A Guide to Better Ideas*. San Francisco: W. H. Freeman and Company, 1974.

ARNHEIM, RUDOLF, *Art and Visual Perception: A Psychology of the Creative Eye*. Berkeley: University of California Press, 1974.

DAITZMAN, REID J., *Mental Jogging*. New York: Richard Marek Publishers, 1980.

DEBONO, EDWARD, *New Think*. New York: Basic Books, 1967.

DEMILLE, RICHARD, *Put Your Mother on the Ceiling*. New York: Penguin Books, 1976.

EDWARDS, DAVID D., *How To Be More Creative*. San Francisco: Occasional Productions, 1979.

GREGORY, R. L., *The Intelligent Eye*. New York: McGraw-Hill, 1970.

KOBERG, DON, AND JIM BAGNELL, *The Universal Traveler*. Los Altos, Calif.: William Kaufmann, Inc., 1973.

KOBERG, DON, AND JIM BAGNELL, *Values Tech:* A Portable School for Discovering & Developing Decision-Making Skills and Self-Enhancing Potentials. Los Altos, Calif.: William Kaufmann, Inc., 1976.

MCKIM, ROBERT H., *Experiences in Visual Thinking*. Monterey, Calif.: Brooks/Cole Publishing Company, 1972.

NELSON, GEORGE, *How to See: A Guide to Reading Our Manmade Environment*. Boston: Little, Brown, and Company, 1977.

RAUDSEPP, EUGENE, WITH GEORGE P. HOUGH, JR., *Creative Growth Games*. New York: Jove Publications, Inc., 1977.

SAMUELS, MIKE, M.D., AND NANCY SAMUELS, *Seeing with the Mind's Eye*. New York: Random House, Inc., 1975.

DRAWING:

BETTI, CLAUDIA, AND TEEL SALE, *Drawing: A Contemporary Approach*. New York: Holt, Rinehart & Winston, Inc., 1980.

BRO, LOU, *Drawing: A Studio Guide*. New York: W. W. Norton & Company, 1978.

CHAET, BERNARD, *The Art of Drawing*. New York: Holt, Rinehart & Winston, Inc., 1978.

EDWARDS, BETTY, *Drawing on the Right Side of the Brain*. Los Angeles: J. P. Tarcher, Inc., 1979.

GOLDSTEIN, NATHAN, *The Art of Responsive Drawing* (2nd ed.). Englewood Cliffs, N.J.: Prentice-Hall, Inc., 1977.

HANKS, KURT, AND LARRY BELLISTON, *Draw! A Visual Approach to Thinking, Learning, and Communicating.* Los Altos, Calif.: William Kaufmann, Inc., 1977.

JAMES, JANE H., *Perspective Drawing.* Englewood Cliffs, N.J.: Prentice-Hall, Inc., 1981.

MENDELOWITZ, DANIEL M., *A Guide to Drawing.* New York: Holt, Rinehart & Winston, Inc., 1967.

SIMONS III, SEYMOUR, AND MARC S. A. WINER, *Drawing: The Creative Process.* Englewood Cliffs, N.J.: Prentice-Hall, Inc., 1977.

BASIC MATERIALS AND TECHNIQUES:

CHAET, BERNARD, *An Artist's Notebook: Techniques and Materials.* New York: Holt, Rinehart & Winston, Inc., 1979.

MAYER, RALPH, *The Artists' Handbook of Materials and Techniques* (3rd ed.). New York: The Viking Press, 1970.

MAYER, RALPH, *The Painter's Craft: An Introduction to Artists' Methods and Materials.* New York: The Viking Press, 1975.

ART/ART HISTORY SURVEYS:

ELSEN, ALBERT E., *Purposes of Art* (4th ed.). New York: Holt, Rinehart & Winston, Inc., 1981.

FAULKNER, RAY, AND EDWIN ZIEGFELD, *Art Today: An Introduction to the Visual Arts* (5th ed.). New York: Holt, Rinehart & Winston, Inc., 1969.

FELDMAN, EDMUND BURKE, *Varieties of Visual Experience* (Basic Edition). Englewood Cliffs, N.J.: Prentice-Hall, Inc. and New York: Harry N. Abrams, Inc., 1967.

GREER, GERMAINE, *The Obstacle Race: The Fortunes of Women Painters and Their Work.* New York: Farrar Straus and Giroux, 1979.

JANSON, H. W., *History of Art* (2nd ed.). New York: Prentice-Hall, Inc. and Harry N. Abrams, Inc., 1977.

KNOBLER, NATHAN, *The Visual Dialogue* (3rd ed.). New York: Holt, Rinehart & Winston, Inc., 1980.

PETERSEN, KAREN, AND J. J. WILSON. *Women Artists.* New York: New York University Press, 1976.

RICHARDSON, JOHN ADKINS, *Art: The Way It Is* (2nd ed.). Englewood Cliffs, N.J.: Prentice-Hall, Inc. and New York: Harry N. Abrams, Inc., 1980.

RUSSELL, STELLA PANDELL, *Art In The World.* New York: Holt, Rinehart & Winston, Inc., 1975.

CONTEMPORARY ART ISSUES:

ALLOWAY, LAWRENCE, *American Pop Art.* New York: Macmillan Publishing Co., Inc., 1974.

ARNASON, H. H., *History of Modern Art.* New York: Harry N. Abrams, Inc., 1968.

ASHTON, DORE, *A Reading of Modern Art.* Cleveland: Press of Western Reserve University, 1969.

ASHTON, DORE, *The New York School: A Cultural Reckoning.* New York: The Viking Press, 1972.

BAKER, ELIZABETH, AND THOMAS B. HESS, eds., *Art and Sexual Politics.* New York: Macmillan Publishing Co., Inc., 1973.

BATTCOCK, GREGORY, ed., *Idea Art: A Critical Anthology.* New York: E. P. Dutton, 1973.

BATTCOCK, GREGORY, ed., *Minimal Art: A Critical Anthology.* New York: E. P. Dutton, 1968.

BATTCOCK, GREGORY, ed., *The New Art: A Critical Anthology.* New York: E. P. Dutton, 1973.

BATTCOCK, GREGORY, *Super Realism.* New York: E. P. Dutton, 1975.

BURNHAM, JACK, *Beyond Modern Sculpture.* New York: George Braziller, Inc., 1968.

CALAS, NICHOLAS, AND ELENA CALAS, *Icons and Images of the Sixties.* New York: E. P. Dutton, 1971.

GELDZAHLER, HENRY, *New York Paintings and Sculpture: 1940–1970.* New York: E. P. Dutton, 1969.

GOTTLIEB, CARLA, *Beyond Modern Art.* New York: E. P. Dutton, 1976.

JOHNSON, ELLEN H., ed., *American Artists on Art: 1940–1980.* New York: Harper & Row Pubs., Inc., 1981.

KRAUSS, ROSALIND E., *Passages in Modern Sculpture.* New York: The Viking Press, 1977.

KULTERMANN, UDO, *The New Sculpture: Environments and Assemblages.* New York: Frederick A. Praeger, Publishers, 1968.

LIPMAN, JEAN, AND RICHARD MARSHALL, *Art About Art.* New York: E. P. Dutton/Whitney Museum of American Art, 1968.

LIPPARD, LUCY, *From the Center: Feminist Essays on Women's Art.* New York: E. P. Dutton, 1976.

LIPPARD, LUCY, *Pop Art.* New York: Frederick A. Praeger, Publishers, 1966.

LIPPARD, LUCY, *Six Years: The Dematerialization of the Art Object from 1966 to 1972.* New York: Frederick A. Praeger, Publishers, 1973.

LUCIE-SMITH, EDWARD, *Art in the Seventies.* Ithaca, N.Y.: Cornell University Press, 1980.

LUCIE-SMITH, EDWARD, *Art Now: From Abstract Expressionism to Superrealism.* New York: William Morrow and Company, Inc., 1977.

MENDELOWITZ, DANIEL M., *A History of American Art* (2nd ed.). New York: Holt, Rinehart & Winston, Inc., 1970.

MEYER, URSULA, *Conceptual Art.* New York: E. P. Dutton, 1972.

ROSE BARBARA, *American Art Since 1900: A Critical History.* New York: Frederick A. Praeger, Publishers, 1967.

ROSENBERG, HAROLD, *The Anxious Object.* New York: Horizon Press, 1964.

ROSENBERG, HAROLD, *The De-definition of Art.* New York: Collier Books, 1973.

RUSSELL, JOHN, *The Meanings of Modern Art.* New York: Harper and Row, Publishers, Inc., 1981.

SANDLER, IRVING, *The New York School.* New York: Harper and Row, Publishers, Inc., 1978.

SONDHEIM, ALAN, ed., *Individuals: Post Movement Art In America.* New York: E. P. Dutton, 1977.

STANGOS, NIKOS, ed., *Concepts of Modern Art* (2nd ed.). New York: Harper and Row Pubs., Inc., 1981.